The John Hay Whitney Collection

THE
JOHN HAY WHITNEY
COLLECTION

JOHN REWALD

National Gallery of Art, Washington

This catalogue was produced by the Editors Office, National
Gallery of Art, Washington. Printed by Princeton Poly-
chrome Press, Princeton, New Jersey. The type is Electra, set
by Composition Systems Inc., Arlington, Virginia. The text
and cover papers are Northwest Vintage Velvet. Designed by
Frances P. Smyth.

Cover: cat. no. 25. Vincent van Gogh. *Self-Portrait.*

Exhibition dates National Gallery of Art, Washington:
29 May–2 October 1983

Library of Congress Cataloging in Publication Data
Rewald, John, 1912-
 The John Hay Whitney Collection.
 "Exhibition dates, National Gallery of Art, Washington:
29 May-5 September 1983"—T.p. verso.
 Bibliography: p.
 1. Painting, Modern—19th century—Exhibitions. 2.
Painting, Modern—20th century—Exhibitions. 3. Whit-
ney, John Hay—Art collections—Exhibitions. 4. Paint-
ing—Private collections—United States—Exhibitions. I.
National Gallery of Art (U.S.) II. Title.
ND189.R48 1983 759.05'074'0153 83-6271
ISBN 0-89468-066-8

Photographic credits

Save for those listed below, all the photographs appearing in
the catalogue were provided by the lenders to the exhibition.

Geoffrey Clements, cat. no. 42
Matthews, cat. nos. 52, 55, 56, 58, 60
Eric Pollitzer, cat. nos. 10, 11, 23, 36, 57, 63, 66, 68, and all
color transparencies
John D. Schiff, cat. nos. 7, 14, 19, 39, 62
Hugh Stern, cat. nos. 15, 30

Contents

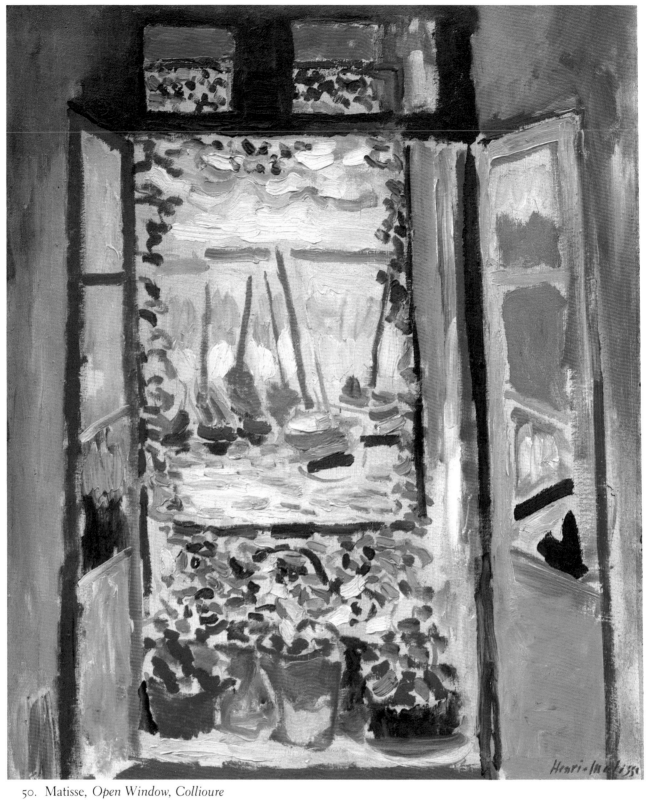

50. Matisse, *Open Window, Collioure*

Foreword

The exhibition of *The John Hay Whitney Collection* is an admiring institutional tribute to one of the National Gallery's great friends and benefactors, a former Trustee (from 1961 to 1979), and distinguished collector in his own right. Jock Whitney served this museum during an important period with an exemplary care and devotion, both as Vice President for many years and as one of four members of the Building Committee for the East Building. Though he followed its planning and construction to the last stages, illness forced him to retire before its formal opening.

Mr. Whitney also made other significant contributions to the Gallery's future: a major gift to the Patron's Permanent Fund for acquisitions and, through a trust established at his death, eight important American and French paintings. These works—by Bellows, Eakins, Whistler, Hopper, Cross, Derain, and Douanier Rousseau—came to the Gallery last December and are included, along with other groups given to the Yale University Art Gallery and the Museum of Modern Art, in this exhibition.

With his wife Betsey, over several decades Mr. Whitney collected across the great movements of modern French art, always unerringly balancing passion and discrimination. This collection is one of the finest gatherings of the masters of modern art still primarily in private hands. Not only are many of the well-known names of nineteenth- and early-twentieth-century painting present here, they are represented almost always with superb examples. Only once previously has the collection been exhibited, and then only a portion, when over twenty years ago the Tate Gallery in London showed a selection at the conclusion of Mr. Whitney's term as Ambassador to the Court of Saint James in 1961. Excepting some small watercolors and drawings of a more personal scale, and a great Manet oil already committed to a retrospective at the Louvre, this exhibition assembles all the major Whitney holdings. The National Gallery is privileged to share this demonstration of a unique and vibrant personal taste.

For making this happy occasion possible we are indebted foremost to Mrs. Whitney, who has allowed us to remove so many treasures from her walls for a long period. We also owe thanks to John Rewald, long-time consultant and scholarly advisor to the Whitneys. He has graciously permitted us to adapt many of his earlier entries on the pictures for the Tate catalogue and has provided a new introduction of great charm and insight. Other entries have been written by members of our curatorial staff: E. A. Carmean, Jr., David Rust, Linda Ayres, Florence Coman, and Deborah Chotner. In addition much help has been given by John Wilmerding, Dodge Thompson, and, in our Editors Office, Frances Smyth and Paula Smiley. We are pleased as well to acknowledge permission of *Art in America* to reprint John Russell's appreciative recollection of Jock Whitney and his collection. In order to make this exhibition complete we needed to borrow from Yale and the Museum of Modern Art the key works Mr. Whitney left to those other art institutions with which he had strong ties, and we thank our colleagues at these museums for their full cooperation.

Jock Whitney had a long life of distinguished national service in many spheres. Not least among his contributions, joined in by Mrs. Whitney, is the art collection which they share here with the public.

He was a lifelong friend and, as well, an exemplar of much of what is best in what America over the centuries has produced. It is to the living memory of John Hay Whitney that this exhibition is gratefully and affectionately dedicated.

J. CARTER BROWN
Director

John Hay Whitney 1904-1982

FOR MUCH OF HIS LONG LIFE, JOHN HAY WHITNEY was one of the most conspicuous men in the country. Not only had he been born to money and power, but he put those advantages to work in a way that was outgoing, debonair, full-blooded and considerate. He was by nature a participant, rather than a spectator, and he made a mark for himself as an athlete, a horseman, a breeder of great horses, a gifted investor in both Hollywood and Broadway, a pioneer venture-capitalist, a pertinacious volunteer in World War II, an innovative philanthropist, and the last publisher of the New York *Herald Tribune*. He was Senior Fellow of Yale and a particularly successful Ambassador to the Court of St. James's.

He also very much enjoyed his connection with *Art in America* magazine, and it is in this context that I should like to commemorate his activity as a collector. This was not a field in which he cared to be conspicuous, and it may well be that no collection of comparable quality was so little publicized. This was very much as he would have wished it to be.

It is now 25 years or thereabouts since I first became aware of the collection of Mr. and Mrs. John Hay Whitney as one of the most remarkable things of its kind.

This revelation occurred to me at Winfield House, the official residence of the United States Ambassador in London. Incoming Ambassadors have often been aware of the power of art to make friends and sway opinion. When they have had paintings, they brought them. When they did not have them already, they either bought them or borrowed them. Sometimes it worked, sometimes it didn't, but it was never in the least what it was in the Whitneys' day.

What distinguished the Whitneys from everyone else was that they did not attempt to make the Embassy into "a show place." They had great paintings, but attention was never drawn to them. (Nor were they ever very large.) When you checked your coat, you saw out of the corner of your eye the study for *Luxe, Calme et Volupté* that Matisse painted in the summer of 1904. This is by common consent a key painting in the evolution of Matisse, but no one was ever led up to it.

A little further into the house there was one of the many versions of Gilbert Stuart's portrait of George Washington. For the American Embassy to have that work was the most natural thing in the world. But the visitor who paused before the Father of the Republic soon became aware of quite another vibration. In an adjoining room, and in sight of us all, was the self-portrait that had been painted at Saint-Rémy by van Gogh in September 1889. To see those two exemplary beings side by side, almost, was a very curious experience.

It was a safe bet, when the Whitneys were in London, that there was no such thing as a dead corner in the house. Nothing was ever pushed under our noses, and it was imperative to look everywhere and if possible have our eyes in the backs of our heads. This was especially true for the American paintings, which at that time were relatively unfamiliar in London. People knew about Courbet, of course, and when they came to Winfield House they recognized the painting of a dog that is a study for part of the *Burial at Ornans*. Balthus had friends in London at that time, and they had made sure that we got the point of his *Le Salon*, 1942, of which Albert Camus had written so eloquently when it was first shown in New York by Pierre Matisse in 1949. But Thomas Eakins was quite another matter, and most visitors who came upon his *Baby at Play* of 1876 were stunned. What could it be, this strange, dense, tenebrous painting of a Herculean man-child? What hand could have wrought those massive passages of still life, those toys so fully and firmly rendered? Could that stately infant be the son of one of Courbet's *Demoiselles des bords de la Seine?*

And this is of course a very peculiar Eakins: a painting in which the great man took a subject all too easily sentimentalized and gave it an almost monstrous finality. This was a baby already full-grown, a thinker before whom the earth shook. It took a very original sensibility to choose that painting. The Whitneys' other Eakins, *The Oarsmen* of 1874, was a natural choice for a collector who had been a considerable athlete in his youth. But the *Baby at Play* taught us to look ever more carefully at what else was in the house.

Something in all this was inherited. John Hay Whitney was the son of Mrs. Payne Whitney, who was a poet as well as a collector. Like most American collectors of her generation, she liked John Singer Sargent. But she didn't only like him in his brisk, external, virtuosic vein. One of the key paintings at Win-

John Hay Whitney

field House was Sargent's wonderfully offhand portrait of Robert Louis Stevenson. One of the least formal portraits ever made of a celebrated writer, this was in Stevenson's view "excellent, but too eccentric to be exhibited." "It is touched in lovely, with that witty touch of Sargent's," he went on, "but of course it looks damn queer as a whole."

This wayward, off-center image looked exactly right at the Whitneys'. Anyone can buy a big formal Sargent, if they have the money, but the portrait of Robert Louis Stevenson set a note of privacy and informality. It told us at once that this was the collection of two people who did not collect to impress, or to fill gaps, or to hoard. They collected what touched them directly.

It was manifestly so. John Hay Whitney had for a long time the advice of John Rewald. One of Whitney's brothers-in-law, James W. Fosburgh, was a man who lived for painting and was himself an accomplished artist. It is perfectly clear that a major Toulouse-Lautrec like the *Marcelle Lender Dancing the Bolero* was owed to the scouting of John Rewald. The little Winslow Homer of the Adirondacks answered to the taste of James Fosburgh, who loved Homer and had lived much in the Adirondacks. But none of that alters the fact that you couldn't go into any room that belonged to the Whitneys and not notice how the pictures seemed perfectly at home.

In the last few years John Hay Whitney did not often come to New York, but the little bedroom that he kept there was something that very few collectors could have carried off without its looking either boastful or contrived. Elsewhere in the apartment pictures of one kind and another and one period and another coexisted, but the high cabin that he kept for himself was in effect a small museum of Picasso. Nothing in it was grand or overbearing, but the concentrated presence of a single artist came across with an astonishing energy and power.

As was natural, John Hay Whitney for much of his life had to do with the public face of art—as a Trustee of the Museum of Modern Art from 1930 onwards, as its President in 1941 and its Chairman from 1946 to 1956, and as a Trustee of the National Gallery of Art in Washington, D.C., from 1961 onwards. But his was fundamentally a private and a companionable view of painting. Sometimes the result was as strong as a major museum; there was an upstairs sitting room at Winfield House, for instance, that had as great a concentration of first-rate Fauve paintings as can be found in any American institution. But they were not forced upon the visitor's attention with trick lighting and spurious "installation." They were simply *there*, as household familiars. It seemed then, and it seems still, the best way to treat wonderful paintings.

JOHN RUSSELL Reprinted with permission from *Art in America*, April 1982.

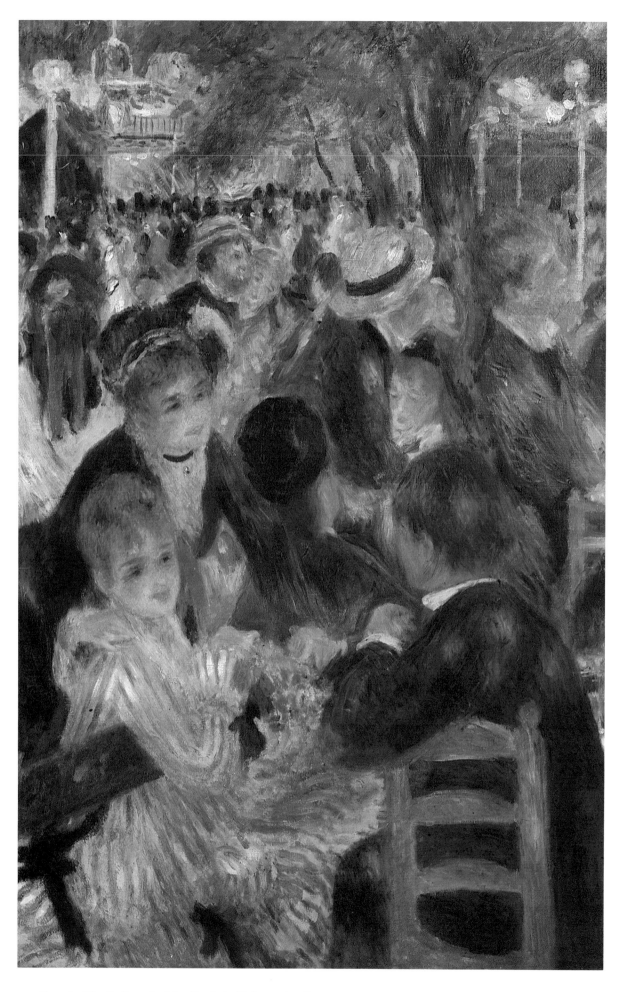

20. Renoir, *The Ball at the Moulin de la Galette*, detail

Introduction

JOHN REWALD

JOHN HAY WHITNEY—or Jock, as everybody called him and as he himself preferred to be called—was a very unusual and discreet human being. A member of what must be considered America's aristocracy and born to tremendous wealth, he was nevertheless a quiet man who shunned the limelight. He earned the respect of those around him not because of his fortune or his generosity, but because he was soft-spoken, courteous, fair-minded, always considerate and willing to listen to others, while at the same time having a great zest for life and a wonderful sense of humor. This is the stuff with which friendships are cemented and which brought him countless loyalties, from both the great and the small denizens of this world. But the fact that he was modest did not mean that he ever hesitated to assume responsibilities of the highest order, be it in war service or as ambassador, as publisher of a leading newspaper, or as innovator in the field of philanthropy. Yet, beside the public servant there was the private man who fully enjoyed all the pleasures and amenities of life without ever feeling guilty or embarrassed about his life-style, and without ever being ostentatious. Actually, he enjoyed these pleasures most when they remained confined to the circle of his family and friends; they ranged from sports, especially polo and racing, to art, and they contributed an important share to the happiness of his daily life. For Jock was a happy man, which does not imply, however, that his multiple activities were not conducted with utmost seriousness; all he did was done well, more often than not exceptionally well.

Though the name Whitney is most significantly linked with American art through the Whitney Museum established by his aunt Gertrude Vanderbilt Whitney, Jock's own interest in art developed along different avenues. It was, to a certain extent, inherited from his mother, Helen Hay Whitney, daughter of John Hay, private secretary of Abraham Lincoln, ambassador to Great Britain, and Secretary of State under Presidents McKinley and Theodore Roosevelt. (On his father's side, he was a grandson of William C. Whitney, who served as Secretary of the Navy under President Cleveland.) Jock's mother was a woman of diverse interests, among which were horse breeding and literature, especially poetry. While she acquired a number of paintings, these were meant primarily as decorations for her homes and, as such, were more or less representative of American taste at the beginning of this century. Nevertheless, among the pictures that hung in the Whitney mansion on Fifth Avenue, designed by Stanford White, were works by Corot, Monet, Renoir, Pissarro, and one pastel each by Manet and Degas, in addition to such American contemporaries as Robert Henri, Arthur B. Davies, and John La Farge. After her death, a number of these were kept by her children, Jock and his older sister, the late Joan Shipman Payson, a well-known collector in her own right; others were bequeathed to the Metropolitan Museum of Art, and still others were disposed of.

Possibly the most noteworthy painting inherited by Jock was Sargent's *Robert Louis Stevenson,* which has stood the test of time and in this exhibition takes its rightful place among the great French paintings of the nineteenth century. Jock's mother acquired some of her modern paintings in the twenties, shortly before he himself began to buy works of art. While a student at Yale, he started collecting on his own, dabbling in sporting prints and Whistler etchings, as well as, a little later, early American portraits. Soon he progressed to more important purchases: two racing pictures by Degas, *The False Start* and *Before the Races,* which still combined two of his pleasures, sports and art. His first truly major acquisition (this is said without any intention of belittling Degas' masterful and exquisite *False Start*) occurred in 1928, when he bought Whistler's *Wapping on Thames,* a work of the artist's early years. With Sargent's portrait of Stevenson, these two works not only represent two American expatriates at their very best, but integrate themselves admirably into the collection Jock was subsequently to assemble: the Whistler harking back to the painter's early exposure to Courbet, while Sargent's daring composition appears distantly related to Degas' unconventional approach to portraiture.

The next important purchase, in 1929, was Renoir's celebrated small version of *Le Moulin de la Galette,* the larger one of which is in the Louvre. This was another decisive step in a new direction, away from pictures connected with Jock's extra-business activities as horse breeder, polo player, and turfman. He was now clearly beginning to involve himself with works that, for want of any other word, can only be called museum pieces. Although the years immediately following these purchases did not produce any important additions to the collection, this did not mean that Jock's interest in art diminished. As a matter

of fact, it grew steadily stronger through his intimate association with the Museum of Modern Art in New York, of which he became a trustee in 1930, within a year of its foundation. Over the years, Jock's sister and his sister-in-law Mrs. James Fosburgh were to become trustees of the Metropolitan Museum of Art; his brother-in-law William S. Paley is currently Chairman of the Board of Trustees of the Museum of Modern Art; his cousins are trustees of the Whitney Museum, on whose board Jock's wife, Betsey Cushing Whitney, also served for some time; and Jock himself eventually joined the Board of Trustees of the National Gallery of Art. This list demonstrates how a civic-minded and art-conscious family has involved itself with many different museums and made a valuable contribution to the cultural life of the nation.

For many years Jock served as Chairman of the Board of the Museum of Modern Art and for some time was also president of its film library (his ties to Hollywood are both historic and well known, but this is not the place to evoke them). On several occasions Jock's connection with the Modern was to enrich his own slowly growing collection, notably when the trustees decided—usually for lack of funds—to pass up a purchase recommended by the museum's director Alfred H. Barr, Jr. The more insistently Barr pleaded for a contemplated purchase, the more carefully Jock listened, with the result that when an acquisition was finally turned down, Barr's eloquence had convinced at least one trustee: Jock simply bought the work for himself, at the same time providing that it would go to the Modern after his death. A number of these pledges has already been redeemed.

Jock saw active service in Europe during World War II, but as soon as he returned to civilian life he again began to buy pictures, and on a much larger scale than before. During the war he had reached the age of forty and, in accordance with the terms of his father's will, had come into complete control of his inheritance. This new situation is reflected not only in his collection, but also in the various projects supported by the John Hay Whitney Foundation. Established with the express purpose of offering opportunities to American students discriminated against by racial or other prejudices, awarding fellowships to high school teachers, enabling small colleges to secure distinguished retired professors, financing projects of national interest, the Foundation's goal was the promotion of various intellectual activities of this country, aid to the underprivileged, and stimulation of worthy causes. At the same time that he was expressing his public-mindedness on an unusually large scale—he himself devoting a great deal of time and energy to the Foundation, while also directing his own business concerns—Jock set out to collect works of art in a more systematic fashion.

In 1942 Jock had married the former Betsey Cushing, a woman of many unusual features. In 1945 she presented her husband with Manet's *Races at the Bois de Boulogne* as a birthday gift. (This is the only important picture of the collection that could not be included in the present exhibition, since shortly before his death Jock agreed to lend it to the large Manet centennial in Paris, after I had pointed out to him that it had not been seen in France since 1884, almost one hundred years.) Betsey Whitney has always shared intensely her husband's interest in modern art. Were it necessary to differentiate between the two, it could be said that Jock was somewhat more level headed and occasionally even detached, whereas Betsey would love (and hate) pictures with a passion. But when Betsey was carried away by her enthusiasm, Jock did not hesitate to defer to her. After all, to acquire a fine painting and make his wife happy at the same time was exactly the kind of solution that appealed to him.

The collection grew steadily and the new additions were extremely impressive. There were two major works by van Gogh, a Saint-Remy landscape and a self-portrait that is considered by many to be the finest he ever painted; both were acquired in 1947. The next year they were followed by an important late landscape by Cézanne, to mention but these three. Yet it is essential to add here that since Jock truly *lived* with his pictures, he could also become weary of some. When a work ceased to satisfy his critical eye or failed to live up to his and Betsey's expectations, he did not hesitate to dispose of it. Although he gave up paintings by Gauguin, Matisse, Picasso, van Gogh, or Bonnard, he was nevertheless ready to acquire others by the same artists. These deletions, however, took place mainly in the late forties and early fifties; for the subsequent twenty-five years the collection grew without any deletions. It may well have been that by then Jock's taste had affirmed itself, so that when he made a new purchase—always in complete accord with his wife—the decision was a final one, never to be questioned.

The fifties were years of tremendous activity, during which a large jungle scene by Henri Rousseau, a blue period Picasso of a young boy, a majestic still life by Cézanne, a Tahitian Gauguin, and Toulouse-Lautrec's sparkling *Chilperic*, a serene landscape by Corot and Courbet's superb *Hound*, an autonomous study for his masterpiece, *The Burial at Ornans* in the Louvre, and many others were added to the collection. It may be worth stating that these purchases were not made according to any preestablished program, and there never was a list of "gaps" to be filled. Decisions were made as works became available

with the collection itself serving as a guide and standard of quality. This meant simply that unless a new offering was definitely superior to works already owned by the Whitneys (something that did not happen frequently), it would be passed up. Unless it was of exceptional importance, no painting was ever acquired because its author was not yet represented in the collection.

If certain artists are missing from this collection, which on the whole represents a survey of French art from the middle of the nineteenth century to the early decades of the twentieth, the reasons may be twofold: no opportunity seems to have presented itself to acquire works by Ingres or Delacroix that would have fully satisfied the Whitneys or that would have "fit" among their pictures; and among the moderns, there were many who, despite their fame, did not appeal to them. This may explain the absence of such painters as Modigliani or Soutine. But then, a private collector has the right to his preferences and prejudices, whereas a museum curator must assemble as complete a representation of any given period as possible. Jock felt quite strongly about this privilege of surrounding himself exclusively with what added enjoyment to his life; he never gave in to the taste of others or, even worse, to any fads. That his pictures would eventually go to public institutions did not mean that he had to collect *for* them.

In spite of this basic attitude, in the fifties the collection was more or less systematically extended in two new directions: neo-impressionist and fauve works were gathered on a preferential basis. Whenever a significant work of these two important and then not yet fully appreciated movements became available, Jock was ready to "grab" it. In cases where a better painting by the same artist subsequently turned up, he would try to exchange his earlier purchase and thus improve the collection. In this way the Whitneys eventually assembled what are possibly the most exceptional groups of neo-impressionist and fauve pictures to be found anywhere. Jock became the last private collector who could boast of owning two canvases by Seurat, yet he was also ready to acquire a lovely harbor scene by the relatively obscure Theo van Rysselberghe, while the still underestimated Henri-Edmond Cross is represented by several paintings, not because he is such an important artist (though his *Grape Harvest* is truly a masterpiece), but because Jock and Betsey deeply enjoyed his delicate and poetic work.

Once, when I discussed with Jock the ultimate disposition of his collection, he said that upon bequeathing his pictures to the three museums closest to his heart, he wished to make it clear that his paintings did *not* have to be hung together but should be dispersed and displayed wherever they best served the institutions' purposes. I could not help pointing out to him that whoever would receive his group of neo-impressionists or fauves would actually *have* to hang them together, since they certainly belonged in the same rooms and would gain their full impact from being seen next to each other. Whereupon he hastened to add with characteristic modesty: "Well, even if that is so, in case the museum that receives them happens to have any fauves or neo-impressionist pictures of its own, I would certainly want those to be hung among mine, where their logical place is. And I count on you to see that this is done."

Since the paintings were dispersed among the various Whitney residences (with a number of fauve pictures hanging in Jock's Manhattan office), it was never really possible to study all of them in one place. It would therefore have been a great joy for those familiar with it to see the collection exhibited; offers to that end were not lacking. But the Whitneys always shied away from such a display of their treasures. Only once did they depart from this policy, and that was more than twenty years ago; it was, moreover, in a foreign country, and the exhibition was far from comprising the entire collection. When Jock Whitney was named Ambassador to the Court of Saint James, in 1956, he took with him to London for his residence there a number of his favorite pictures. It was there that John Russell, now art critic of the *New York Times*, first saw them, as did many others. It seems only natural that various British friends—and they had many—should have prevailed upon the Whitneys to show these paintings publicly before shipping them back to New York in 1961. The exhibition was to be held at the Tate Gallery. But since the initial selection had been made on a strictly personal basis which did not completely reflect the collection's breadth nor necessarily comprise all of its most outstanding works, I was able to obtain Jock's permission to select ten more paintings that would provide a more comprehensive idea of the collection. These were sent to London especially for this show, which took place from December 16, 1960 to January 29, 1961.

During his tenure in London, Jock and Betsey had increased the collection by a few purchases, such as, notably, Daumier's *Card Players* and Vuillard's *Woman Embroidering*. After their return to the States, their collecting activity slackened somewhat though Jock was among those who—under the auspices of the Museum of Modern Art—participated in the purchase of the pictures from the Gertrude Stein estate. In this way he acquired an exceptionally fine group of Picasso's cubist works and enriched his collection significantly, since cubism had not yet been sufficiently represented in it. Strangely enough, these cubist canvases, the last major additions to his collection, soon became particularly dear to him. His bedroom in his Manhattan home was hung exclusively with Gertrude Stein's Picassos and one oval still life

by Braque that is stylistically almost indistinguishable from contemporary work by Picasso. With the exception of a few works by some younger Americans, the cubist group represents, if one may put it thus, the ultimate phase of modern art in the Whitney collection.

This, then, is the story behind the collection which is exhibited here in all its richness and diversity for the first and probably also for the last time. Upon his death early in 1982, Jock left his pictures to Betsey, though he had expressed certain wishes as to the final disposition of his collection. Since then Betsey Whitney has lived with the desire to execute her husband's wishes and to do so in many cases as soon as possible. As a result, a number of the paintings shown here has already been presented to the Yale University Art Gallery, to the Museum of Modern Art in New York, and to the National Gallery of Art. They are included in this exhibition as loans from these institutions.

Jock leaves behind a splendid and precious gift to all Americans. Future generations are bound to be thrilled by his bequests, through which the masters of bygone days continue to address themselves to ever new lovers of art. Jock did not want his collection turned into a mausoleum, he did not want his memory to overshadow his pictures . . . all he wanted was to share with the future what he himself had loved and enjoyed.

I don't believe it is an exaggeration to say, not only on our behalf but also on behalf of all those to come in the tomorrows ahead of us, that we are deeply grateful to him.

Note to the Reader

Entries 1-6, 8, 10-12, 16-18, 20-33, 37, 41-45, 48, 50-51, 53-54, 61-62, 64, 68-70, 72-73 are taken from the catalogue *The John Hay Whitney Collection*, written by John Rewald to accompany an exhibition held at the Tate Gallery, London, from 16 December 1960 to 29 January 1961. We are most grateful to the Tate Gallery for permission to use this material. The remaining entries were prepared by the staff of the National Gallery of Art.

Unless otherwise noted, all paintings are lent by Mrs. John Hay Whitney.

Pre-impressionism

Frédéric Bazille
1841-1870

1

Potted Plants, 1866
oil on canvas, 38¼ x 34⅝ in.
signed and dated in lower left corner:
F. Bazille 66

In 1864 Monet advised Bazille to paint flowers as he himself had just done. This advice was followed that same year by Renoir, who often shared Bazille's studio, and a little later by Bazille himself (it may also have inspired Boudin to do his only known flower paintings. The close communion of work and thought which then existed between Monet, Renoir, and Bazille conferred upon their work of those early, formative years a certain similarity. All three chose predominantly white blossoms enhanced by colorful accents and dark backgrounds, but each already revealed certain personal characteristics. Monet's still lifes of flowers are vigorously and broadly brushed in; Renoir's paintings of potted plants are a little softer in color and more delicately executed; Bazille's rare flower pieces, of which this is the first, are distinguished by more powerful contrasts and a greater solidity, the result of the deep seriousness with which he compensated for whatever he may have lacked in imagination. Endowed neither with Monet's strength nor Renoir's facility, the young artist overcame his awkwardness and timidity through a constant effort humbly to penetrate the mysteries of nature.

Bazille presented this canvas to his cousins, Commandant and Mme Lejosne in Paris, in whose house he dined regularly once a week and where he met some of the most fascinating—though not yet famous—personalities of his time. Indeed, the circle of the Lejosnes included Baudelaire and Manet as well as Cézanne, Fantin-Latour, Nadar, Gambetta, and many others. (Likenesses of M. and Mme Lejosne, of Baudelaire, Théophile Gautier, Champfleury, Offenbach, Fantin-Latour and various other friends or acquaintances are included in Manet's *Concert at the Tuileries Gardens* in the National Gallery, London.) At the gatherings in the Lejosne home Wagner's then highly controversial music, advanced literature, poetry, and painting were regular topics of animated conversation. Thanks to his cousins, Bazille thus became familiar with all the new art currents. He must have selected with particular care the work through which he was to be represented on their walls.

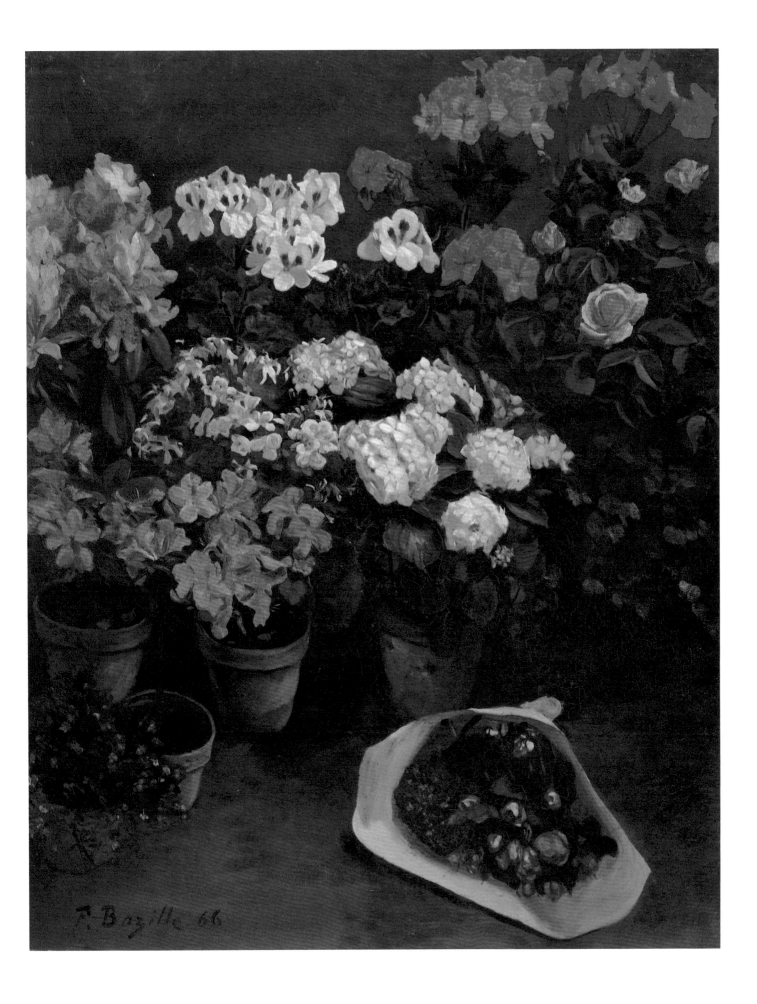

Eugène Boudin
1824-1898

2
Hollyhocks, 1858-1862
oil on canvas, 23½ x 18¼ in.
signed in lower left: *E. Boudin*

3
Roses, 1858-1862
oil on canvas, 23¼ x 18 in.
signed in lower right: *E. Boudin*

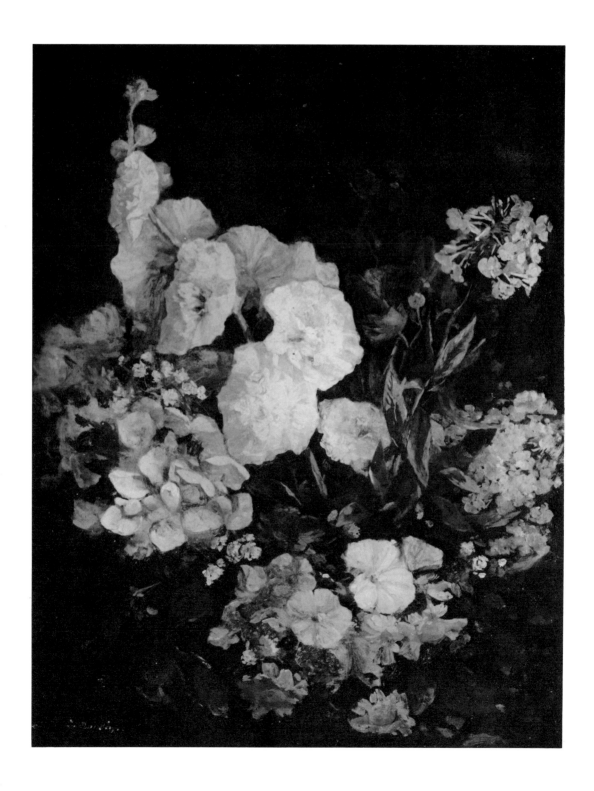

This pair of flower still lifes is most unusual for Boudin. No similar paintings are known, nor can their date of execution be ascertained. During the summer of 1864 Monet and Bazille had been staying at the rural inn of Saint-Siméon above the Seine estuary near Honfleur, which has been called the "Barbizon of Normandy." After Bazille had left, Monet wrote to him in the autumn:

"There are a lot of us at the moment in Honfleur. . . . Boudin and Jongkind are here; we are getting on marvelously. I regret very much that you aren't here, because in such company there's a great deal to be learned and nature begins to grow beautiful: things are turning yellow, grow more varied; altogether, it's wonderful. . . . I shall send a flower picture to the exhibition at Rouen; there are very beautiful flowers at present. . . . Now do such a picture, because I believe it's an excellent thing to paint."

It might well be that Monet's enthusiasm for flowers was infectious enough to induce Boudin to abandon his landscapes and studies of skies which Baudelaire had recently admired, in order to tackle a similar subject. Delicately colored and painted with subtle but almost vigorous strokes, these still lifes represent a unique note in Boudin's oeuvre.

Camille Corot
1796-1875

4

Cottage and Mill by a Torrent (Morvan or Auvergne), 1831
oil on canvas, 20⅞ x 25¼ in.
signed and dated in lower left corner:
COROT 1831

"The early Corots," Duncan Phillips has said, "in their sparkling clarity, their variety of textures and their firm structure, are among the truest and most admirable pictures ever painted, comparable to that earliest masterpiece of enchanted realism, Vermeer's *View of Delft*. In their subtle register of spatial values and their unfailing tonal harmonies they belong to the same happy family as Chardin's best still life."

Among the works of his early period, overshadowed during the artist's lifetime by his later pictures, but which since have come to be recognized as his most significant paintings, this landscape which combines serenity with forcefulness, poetry with an intense realism, occupies a unique position for, as Germain Bazin has written, "the vivid coloration and the strong southern light [although Morvan is in the center of France rather than in the south] are exceptional in Corot's *oeuvre*." (G. Bazin, *Corot* [Paris, 1951], no. 33.)

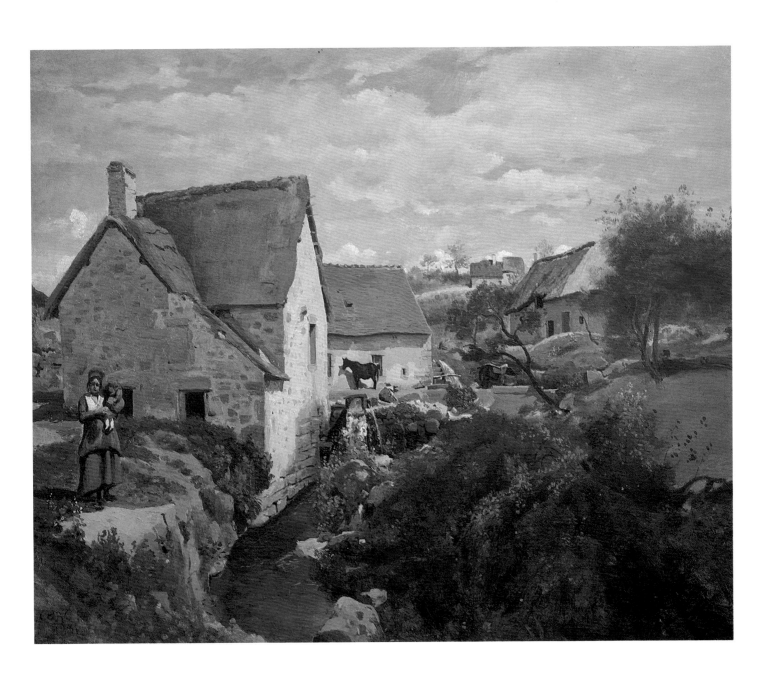

21

Gustave Courbet
1819-1877

5
The Hound, from *Burial at Ornans*, 1856
oil on canvas, 25½ x 32 in.
signed and dated in lower left corner:
G. Courbet 56

The *Burial at Ornans*, now in the Louvre, painted during the winter 1849-1850, was Courbet's first large composition and his first work devoted to a contemporary subject. It measures more than 11 ft. by 23 ft. and was executed in his recently built studio in Ornans which was only 16 in. longer than the canvas. About 14 ft. wide, this studio never afforded the artist an opportunity to view the picture as a whole from a proper distance. In spite of the practical difficulties and the necessity to summon his more than forty models one by one for their life-size likenesses, Courbet apparently carried out his work in only a few months. When the huge painting was shown at the Paris Salon of 1850, it attracted much attention but received little praise, most critics considering it ugly and vulgar.

A preparatory drawing for the composition, which bears comparatively little resemblance to the final arrangement of the mourners and other figures that occupy the entire length of the canvas, does not show the white dog which is set so conspicuously in the foreground of the painting, contrasting with the compact black dresses of the women behind. But in a letter to his friend Champfleury, Courbet, reporting on the work in progress, wrote somewhat jokingly: "Those who have posed so far are the mayor who weighs 400, the curé, the justice of the peace, the cross-bearer, the notary . . . the choir-boys, the gravedigger, two veterans . . . a hound, the corpse and the coffin-bearers. . . ."

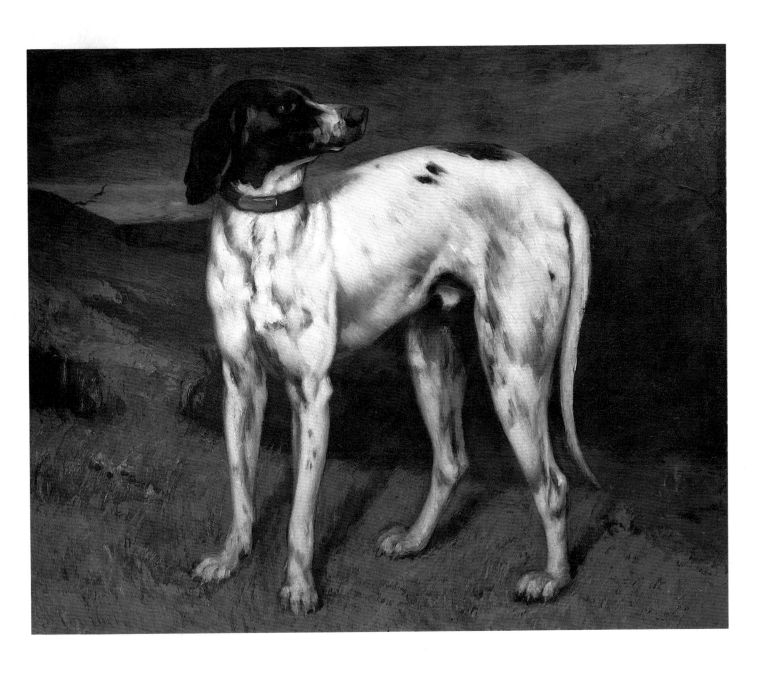

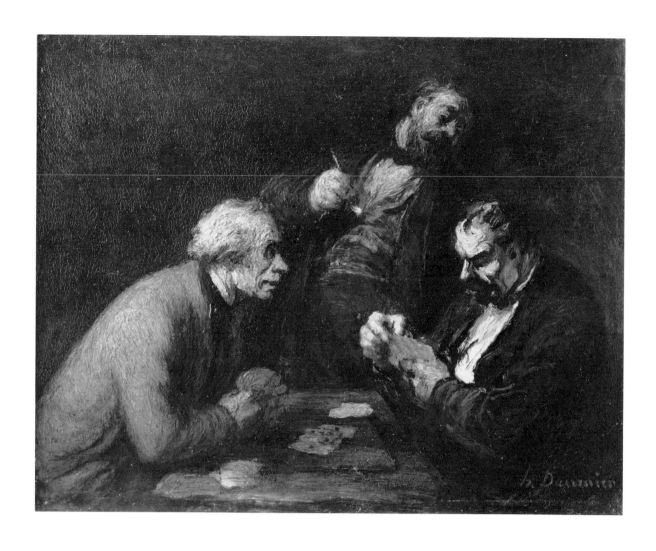

Honoré Daumier
1808-1879

6
The Card Players, 1859-1862
oil on wood panel, 10½ x 13½ in.
signed in lower right corner: *h. Daumier*

Though famous in his own day as a draftsman and caricaturist, as a bitter foe of the successive more or less despotical rulers of France, and as a merciless satirist of the French bourgeois, Daumier remained practically unknown as a painter. The first major exhibition of Daumier's work in 1878 —the only one-man show organized during his lifetime—at last revealed, though without much success, the painter who has since taken his place next to Ingres, Delacroix, Corot, and Courbet as one of the most original masters of the first half of the nineteenth century.

In his recollections Durand-Ruel reports: "In order to attract attention for Daumier, then old and sick, unable to work and consequently without means, all his friends and admirers organized a general exhibition of his works in my galleries [with Victor Hugo as honorary president]. It comprised 94 paintings, 139 watercolors or drawings, some sketches in plaster . . . not to mention a complete collection of his finest lithographs. The catalogue included an introduction by Champfleury. This remarkable exhibition aroused great interest among true art lovers but had no success whatever with the general public." (See "Mémoires de Paul Durand-Ruel" in L. Venturi, *Archives de l'Impressionnisme* [Paris-New York, 1939], 2, 207-208.) Daumier's posthumous fame began to grow a quarter of a century later when a large retrospective exhibition was held at the Ecole des Beaux-Arts in Paris. His painting of *The Card Players* was shown in both these historic exhibitions.

This work belongs to a group of pictures which portray the middle-aged well-to-do bourgeois in his leisure hours: he is playing chess, dominoes, or tric-trac, or he is sitting at a table, at peace with congenial friends, drinking and smoking. With the light concentrated on the essential features and all three figures vigorously modeled in Daumier's usual subdued color scale, this painting illustrates the artist's two outstanding characteristics: an astute observation of human expression and a powerful, almost dramatic tension bestowed on an ordinary moment of daily life.

Alfred de Dreux (Dedreux)
1810-1860

7

White Horse Frightened by a Storm
oil on canvas, 21 x 17½ in.
signed in lower right: D.D.

Like Géricault, in whose footsteps he followed, de Dreux was a painter of horses, but in his case to the extent that he practically never depicted anything else. "My specialty is painting the portraits of people on horseback," he wrote to Louis-Philippe's Minister of the Interior, when the latter commissioned a likeness of the king's son, the Duke of Orleans. And in this specialty he attained a rare perfection, creating an art both elegant and romantic, fashionable and individual, sophisticated and pastoral.

Whereas Louis-Philippe's relations with England were rather strained, those of de Dreux with the British Isles could not have been better. Each year he showed at the Paris Salon and subsequently at the Royal Academy in London. His subjects included not only French royalty, Louis-Philippe and his sons as well as his successor, Napoleon III, but also Queen Victoria and members of the British nobility. His success was as brilliant as the fashionable world he painted. His position may be compared to that of his contemporary, Offenbach, and like the musician he is now experiencing a second vogue one hundred years after his first.

The romantic devices of Géricault are evident here. The strong light from the left is contrasted with the shadows on the right, adding to the drama and excitement of the animal surprised by natural forces.

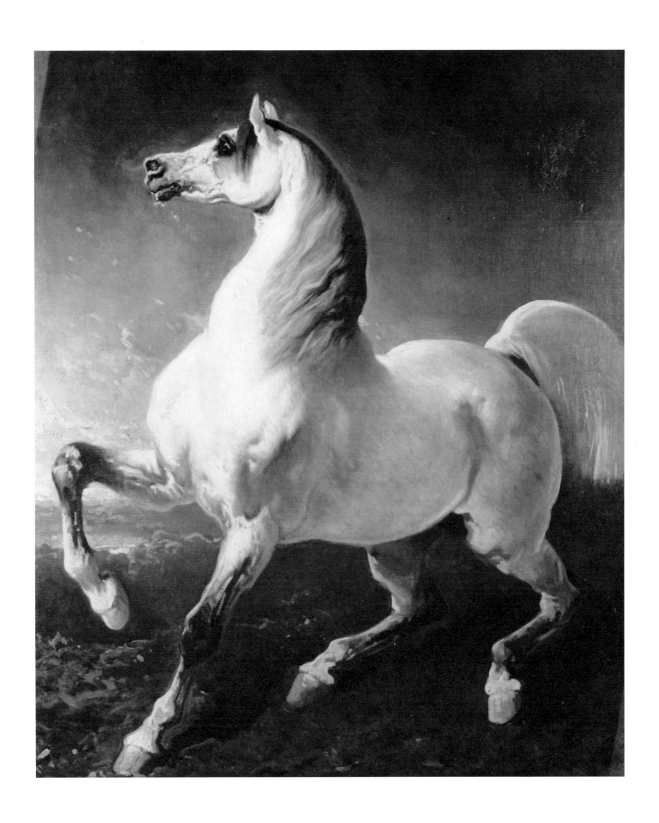

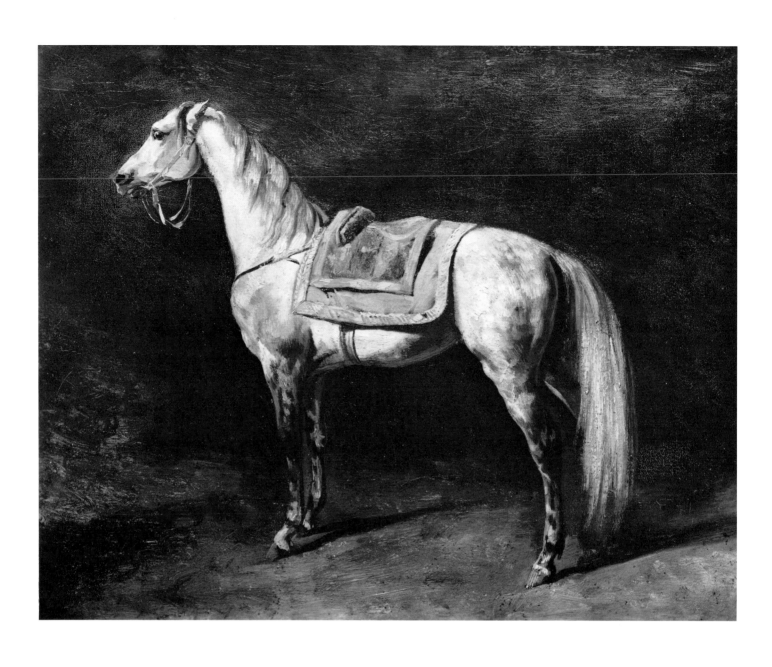

Théodore Géricault
1791-1824

8

Napoleon's Horse, c. 1815 (?)
oil on canvas, 14³⁄₁₆ x 17³⁄₄ in.

Géricault's biographer, Charles Clément, catalogued this painting almost a century ago and described it in these words: "Horse of Napoleon. It is white, Arabian, of extremely elegant proportions, saddled, bridled, ready to move off. This picture which, it is said, earned Géricault a gold medal from the Empress Marie-Louise, is supposed, according to family tradition, to represent a horse of Napoleon which Géricault allegedly painted from nature about 1815." (C. Clément, *Géricault, étude biographique et critique avec le catalogue raisonné de l'oeuvre du maître* [Paris, 1879, third edition], 290-291.)

The author's cautious wording is easily explained by his reluctance to contradict the owner's story which, in fact, seems in conflict with historical events. Napoleon abdicated in April 1814, and, on his return to power in February of the following year, for one hundred days, Géricault chose to accompany King Louis XVIII into exile. Although the painter soon returned to Paris, he is not likely to have painted the emperor's horse in those turbulent days, loyal follower of the Bourbons that he was. Either the painting was done between 1810 (the date of Napoleon's marriage to Marie-Louise of Austria) and his abdication four years later—or it was executed around 1815 and in that case probably does not represent the emperor's mount.

Be this as it may, the artist restrained his romantic passion and approached his subject with the professional interest of a lover of horses rather than with the dramatic fervor of a history painter confronted with the stallion that carried France's most famous leader. A white animal against a dark background, a simple pose, a few color accents, these were the only problems that appear to have preoccupied him. Any attempt at idealization has been avoided. But the brushwork is vibrant and deft, contrasts are subtly emphasized, and there is an undefinable dignity and pride about the horse which seem to indicate that an Arabian *pur sang* needs no props to show off its high status.

Théodore Rousseau
1812-1867

9
The Isle of Capri, c. 1830/1832
oil on canvas, 10½ x 16 in.
signed in bottom right: *TH R CAPRI* (TH in monogram)

In this vigorously executed painting, Théodore Rousseau depicted a visitor's initial view of the perennially popular resort island of Capri, seen from the rocky headlands off Naples. The darker cliffs in the foreground form an effective foil for the rugged crags and grassy slopes of the island beyond, bathed with warm sunlight and surrounded by the calm azure water. Rousseau's fresh color and fluid, summary brushwork, indicative of the influence of English painters like Bonington and Constable, give the painting the immediacy and spontaneity of a *plein air* sketch.

The style of *The Isle of Capri*, fully consistent with such works of Rousseau's youth as *Paysage d'Auvergne* (Paris, Collection of Comte Doria) and *Vue d'Auvergne* (Birmingham, Barber Institute of Fine Art), suggests that this was painted be-tween about 1830 and 1832. The freshness of its execution might suggest that this was painted on the site, but Rousseau is never known to have visited Capri; indeed, except for a brief visit to neighboring Switzerland, no excursions outside France by Rousseau have ever been documented. Since it is an early work, Rousseau might have copied the scene from another painting, but no such source has been discovered. It is possible, then, that this painting is evidence of a previously unknown voyage outside France made by Théodore Rousseau at an important early stage in his career and provides insight into a hitherto undiscovered aspect of the development of France's most important nineteenth-century landscape painter prior to the impressionists.

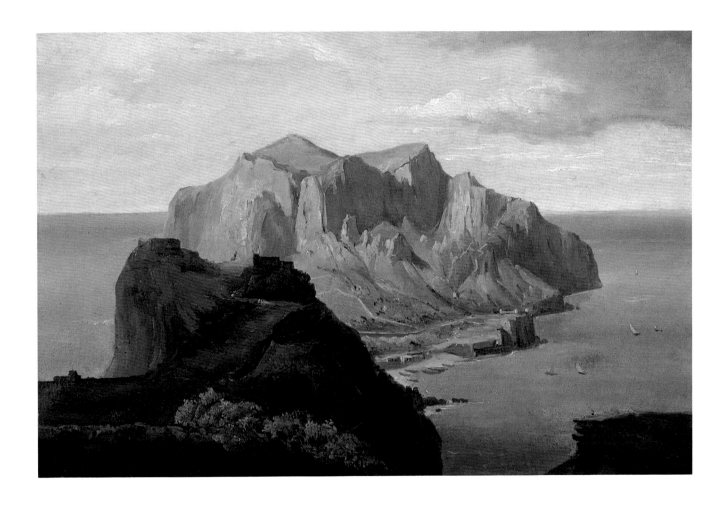

Impressionism

Edgar Degas
1834-1917

10
Self-Portrait, c. 1862
oil on paper mounted on canvas,
20½ x 14½ in.
stamp of Degas estate in lower right corner

Degas painted at the same period two likenesses of himself with open collar and slightly dishevelled hair, very unlike his neat appearance in most of his other self-portraits. The sparing use of color as well as the artist's strange and impenetrable expression further set this painting apart among his early works. This led M. Guérin to comment that this picture is distinguished by a certain romantic and almost dramatic attitude "seldom to be found in Degas' work and which differentiates it from previous portraits, so simple and of such peaceful gravity. The artist has painted himself here in a studio smock, his face anxious and tormented. . . . Was this intentional? Is it merely the unconscious reflection of preoccupations, sufferings or worries of the moment? We do not know the intimate life of Degas and it is impossible to make any conjectures." (M. Guérin, *Dix-neuf portraits de Degas par lui-même* [Paris, 1931].)

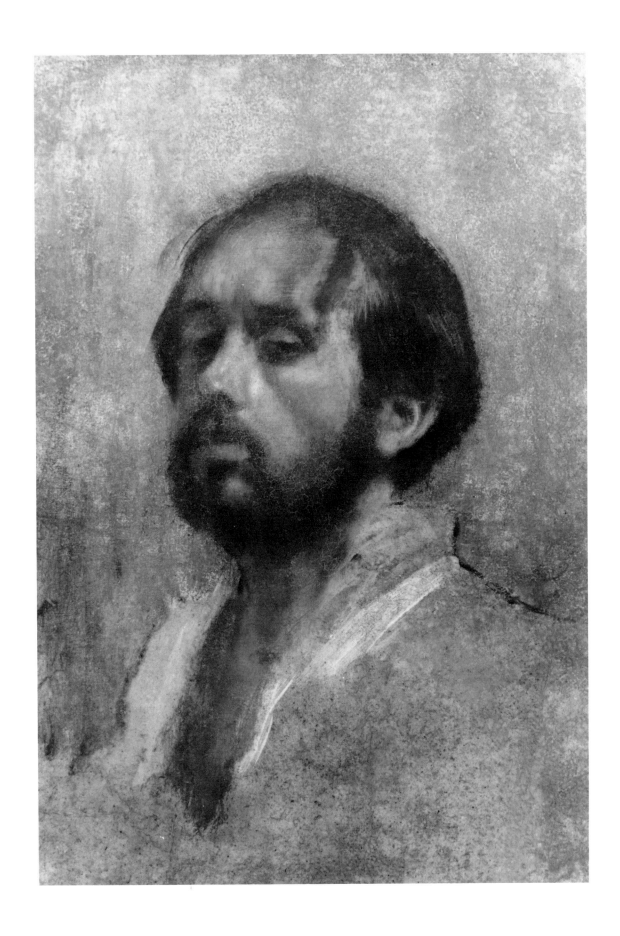

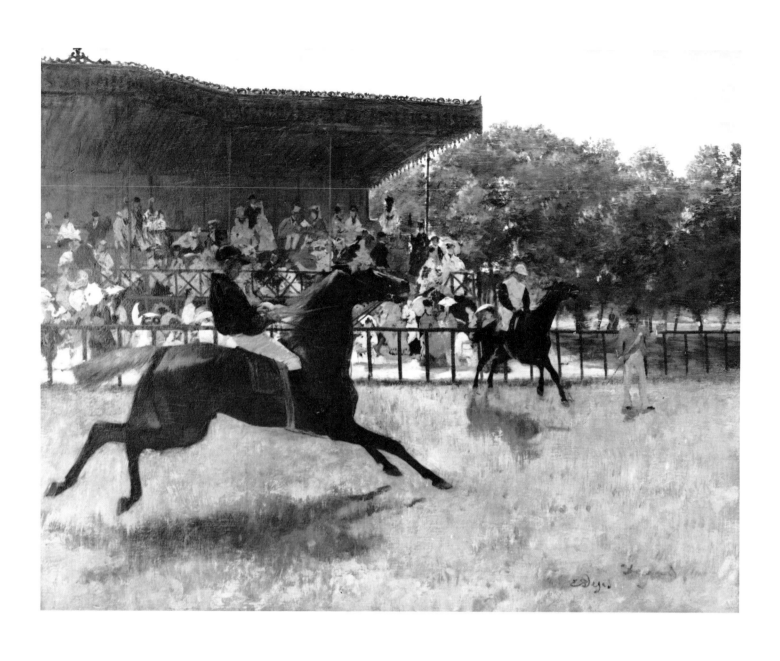

Edgar Degas

11
The False Start, 1864
oil on panel, 12⅝ x 15¾ in.
signed in lower right: *E Degas*, and,
partially overpainted: *Degas*
Yale University Art Gallery, John Hay
Whitney, B.A. 1926, Honorary M.A. 1956,
Collection

Degas never concealed his opposition to working out of doors as practiced by his impressionist colleagues, one of his reasons being that the old masters had never done so. He preferred to make sketches on the spot and to entrust most features of his subjects to his memory. Whereas his friends, in the years before the historic first impressionist group show of 1874, insisted with growing emphasis that they could represent what they saw only by studying their motif while they worked, Degas adopted the opposite procedure and showed an increasing tendency to observe without actually painting and to paint without observing. The result of this attitude was the superb clarity of definition of works such as *The False Start*, arrived at through work in the studio where no hazards of atmospheric conditions could detract from the precise image the artist had memorized.

Degas had "discovered" race tracks as a source for a variety of modern subjects and took a certain pride in the fact that he had preceded Manet in this. This painting is one of the first he devoted to race courses. It is, in the words of Daniel Catton Rich, "carefully planned with large areas of flat, rather restrained color and carefully realized silhouettes of the horses and riders. By pushing the running horse and grandstand to the left of his canvas he was able to suggest space into which they seem about to move. In the background he blurred the watching crowd, scattering little notes of blues, salmon, rose and moss-green, lending animation to the scene and contrasting with the broader passages of tans, browns and blacks. Always sensitive to light, the painter floods his picture with the cold outdoor illumination of Paris. Shadows are kept at a minimum and the whole scene united by that exquisite scale of values which Degas employed at this period." (D.C. Rich, *Degas* [New York, 1951], 48.)

It is by no means impossible that the boldly silhouetted horse and rider in the foreground, as well as the massive expanse of the grandstand with its delicately outlined ornaments, were inspired by Japanese prints which Degas studied particularly in those years. The asymmetrical composition was also a device he often borrowed from Far Eastern art.

Edgar Degas

12

Before the Race, 1881-1885
oil on paper, laid on cradled panel,
12 x 18¾ in.
signed in lower left corner: *Degas*

Race horses were for many years one of Degas' favorite subjects. Like the young dancers whom he drew and painted again and again in their ballet classes, thoroughbreds provided the artist with an opportunity to study bodies in movement. Yet the movement that attracted him was not free and spontaneous, indeed quite the contrary: it was controlled by training, submitted to rigorous discipline, deriving its extraordinary elegance precisely from the laws that governed it. It was movement in accordance with a logic with which the painter was intimately familiar. Thus he could depict horses in an infinite variety of attitudes without becoming repetitious.

Despite its small size, this painting is the result of numerous preparatory studies; it is one of the few instances in which there exists a drawing that almost exactly defines the final composition. The particular effectiveness of the composition is derived from the diagonal of the left horse's head and the neck of the second horse, thrusting toward the onlooker, which divides the picture plane and is masterfully balanced by a diagonal in the opposite direction, constituted by the horse galloping toward the right, with the barely visible horse and rider in the far distance as the final point of a triangle.

When, in 1908, the French critic Louis Vauxcelles commented on this painting—the artist was then seventy-four years old—he wrote: "Monsieur Degas, the foremost draftsman of our time, a profound psychologist, cruelly misogynous, has captured with his corrosive line . . . the various movements of jockeys. Monsieur Degas is appreciated only by an *élite*. Famous and mysterious, he is among those of whom it can be said that they are working for the museums of the future with practically nobody aware of it." (L. Vauxcelles, in *Les Arts,* September 1908, 26.)

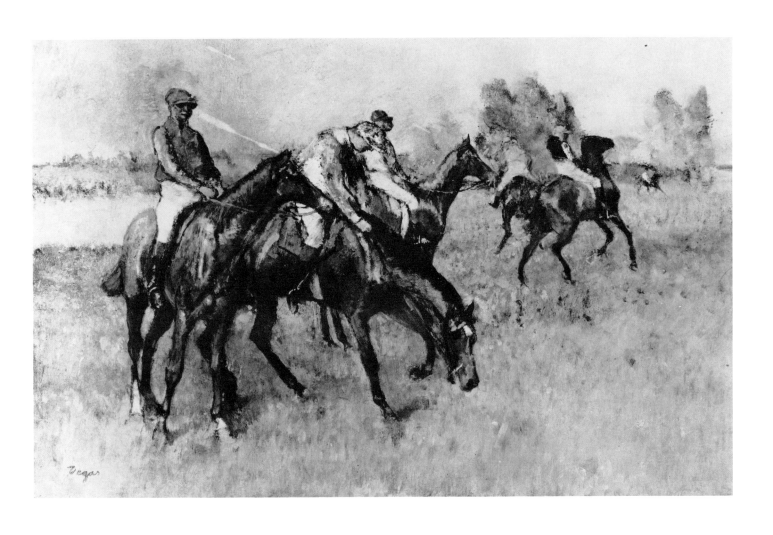

Edgar Degas

13
Landscape with Mounted Horsemen,
1883-1890
oil on canvas, 15½ x 35 in.
signed bottom left: *Degas*

The actual subject of this painting is not horse racing; Degas only occasionally depicted the action of a race or the picturesque activities and people associated with them. Unlike de Dreux and Géricault, both reportedly fine equestrians, Degas probably could not ride. Further, in the paintings in this exhibition, de Dreux and Géricault treated their horses in a manner foreign to Degas; he had no taste for their energetic and romantic portrayals. The main reason that Degas repeated these representations of horses is identical to that for his other recurring subjects: he wanted to express in pictorial terms the shapes and motions of bodies engaged in the performance of habitual activity.

In the early 1880s, with the new information of the Muybridge photographs, Degas increasingly focused on the figures of horses and jockeys, reducing landscape backgrounds to a few slightly articulated essential bands of color and almost entirely eliminating spectators. The horizontal composition and the friezelike disposition of the horses in *Landscape with Mounted Horsemen* was probably inspired in part by Gozzoli's *The Procession of the Magi* (Palazzo Riccardi, Florence), which Degas copied in 1860 when he studied in Italy. Additionally, Degas' line of five horses may be a simultaneous representation of the progression of one single horse, similar to the sequential photographs of Annie G. taken by Muybridge.

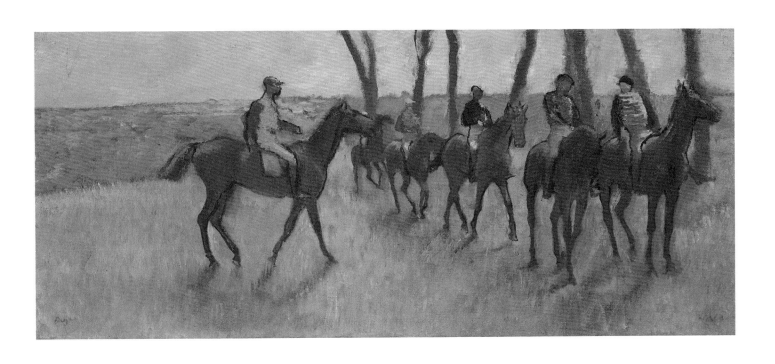

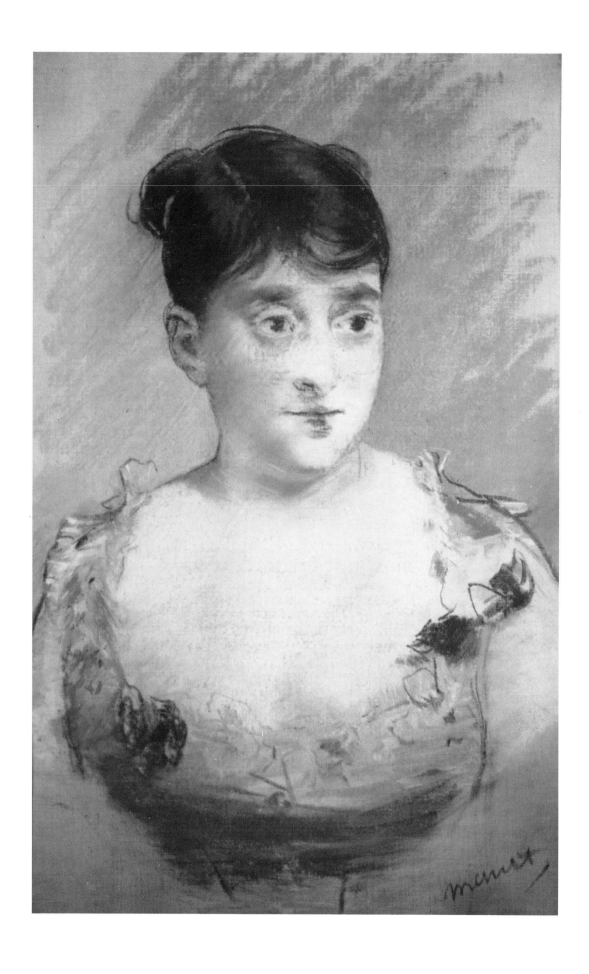

Edouard Manet
1832-1883

14
Woman in a Décolleté Gown (Portrait of Madame Du Paty), 1880
pastel on canvas, 21¾ x 13⅞ in.
signed bottom right: *Manet*.

Woman in a Décolleté Gown (Portrait of Madame Du Paty) dates from the final phase of Manet's career. His limbs were badly affected by loco-motor ataxia, the disease which led to his death in April 1883, so he was unable to continue frequenting the boulevards and cafés of his beloved native Paris. He retired to Bellevue, a short distance outside the city, during the summer of 1879. There, he enjoyed entertaining many Parisian friends, most of whom were women, demi-mondaines as well as ladies like Madame Du Paty, the cultivated and sophisticated wife of Léon Du Paty, an artist who specialized in academic genre and history paintings.

A major consequence of the debility he suffered was that Manet found it increasingly arduous to stand at an easel. The painting *A Bar at the Folies-Bergère* (Courtauld Institute of Art, London), from 1881, was his last major oil; the remainder were mostly small-scale, quickly executed still lifes and landscapes of his garden. Manet turned instead to pastels; he quickly became adept in the medium, using nuances of technique markedly different from those he practiced with oils. Unlike oils, pastels contain almost no binder to hold the nearly pure pigments to the surface of a work, making the medium very delicate while allowing a fidelity to naturally observed color not possible with oil paints.

Although the delicate chalklike sticks of clear colors were still relatively new to him, Manet evinces a deft sureness in their application throughout this portrait. He achieved the sensitive modeling of the sitter's sensuous flesh by carefully rubbing the colors, while the fabric of her dress is evoked with numerous soft touches. Single sharp lines in areas such as nose, mouth, ears, neck contour, and right shoulder, vividly articulate her face and figure. The penetrating, poignant characterization in the *Woman in a Décolleté Gown (Portrait of Madame Du Paty)* evidently pleased Manet, since the artist showed it almost immediately, at the 1880 exhibition *Oeuvres nouvelles d'Edouard Manet*, held in the gallery of the progressive journal *La Vie Moderne*.

Claude Monet
1840-1926

15
Camille on the Beach, Trouville, 1870
oil on canvas, 16 x 18½ in.
signed and dated bottom left: *Claude Monet—70*

Following their June 1870 wedding, Claude Monet, his wife Camille, and their young son Jean vacationed at Trouville, on the north coast of France. There they met Eugène Boudin and his wife, and while their families relaxed on the beach, the two artists worked together as they had done earlier. Much later Boudin reminded Monet of the pleasant period in a letter: "I can still see you with that poor Camille at the Hôtel de Tivoli. I have even preserved from that time a drawing that represents you on the beach. Three women are there in white, still young. Death has taken two, my poor Mary Ann and your Camille. . . . Little Jean plays in the sand and his papa is seated on the ground, a sketchbook in his hand—and does not work. It is a memory of that time that I have always preserved piously." (Boudin letter, cited in W. C. Seitz, *Claude Monet* [New York, 1960], 86.)

It was because of Boudin's encouragement in about 1855 to 1858 that Monet began to paint seriously; following the elder's advice, Monet started sketching and painting directly from nature in the region near his native Le Havre. The nine known surviving works painted by Monet during the summer of 1870 are *plein air* paintings, with the fresh colors and spontaneous execution Monet gained by following Boudin's advice. The freedom of his brushwork exceeds Boudin's, though daubs define the bathers and just a few swift strokes indicate Camille's eyes and veil.

In *Camille on the Beach, Trouville* Monet combined direct observation with a vantage point carefully selected to create an effective and innovative composition. Seen from below, Camille lounges in a beach chair in the immediate foreground, her skirt arbitrarily cut off by the bottom edge of the painting. This unusual framing device and her steady gaze at the painter set Camille apart from the lively beach activity behind her, clearly demonstrating the artist's affection for his wife and the intimacy of this newly wed couple.

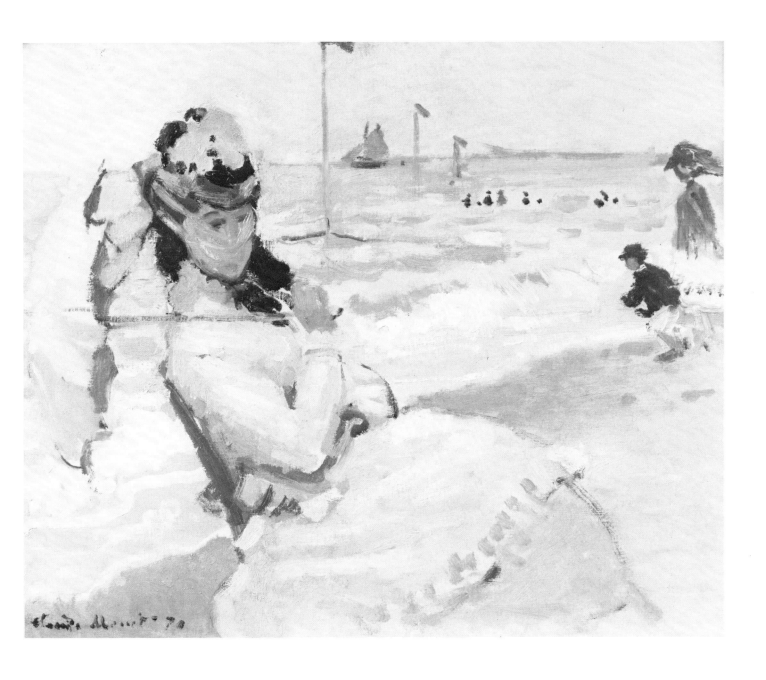

Claude Monet

16
Boats on the Beach, Etretat, 1885
oil on canvas, 28½ x 36¼ in.
signed and dated in lower left corner:
Claude Monet 84

Like Braque almost half a century later, Monet grew up in Le Havre and roamed the Normandy coast during his formative years, frequently in the company of Boudin, Jongkind, and Courbet. Again like Braque, he completely abandoned the haunts of his youth, returning there only after an absence of many years. But when he went back to Etretat, Dieppe, Pourville, etc., in the early eighties, it was to paint there a number of his finest works, though he seems to have avoided the subjects that had once attracted him. After a period of doubts and depression subsequent to the death of his first wife in 1879, the artist slowly regained his self-confidence, but oscillated between canvases of great subtlety and others done with tremendous vigor and forceful colors.

Guy de Maupassant, who watched him work on the coast, marveled at seeing Monet "seize a glittering shower of light on the white cliff and fix it in a flood of yellow tones which, strangely, rendered the surprising and fugitive effect of that unseizable and dazzling brilliance." In contrast to such studies of atmospheric conditions that already announce Monet's later series of haystacks, poplars, etc., are paintings such as this with their heavy pigment, their powerful statement, their striking composition, and their vibrant colors. Here and in similar works of the same period Monet appears like a forerunner of the fauves, not so much because he exaggerates the features of his subjects—as they were to do—but rather because he selects subjects which offer simple elements and strong contrasts, treating them without attempting to soften their stark properties.

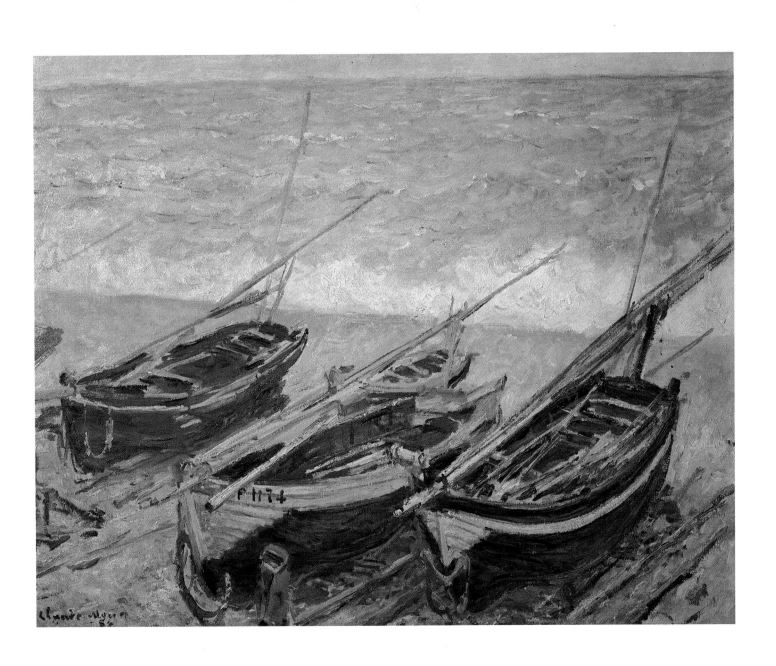

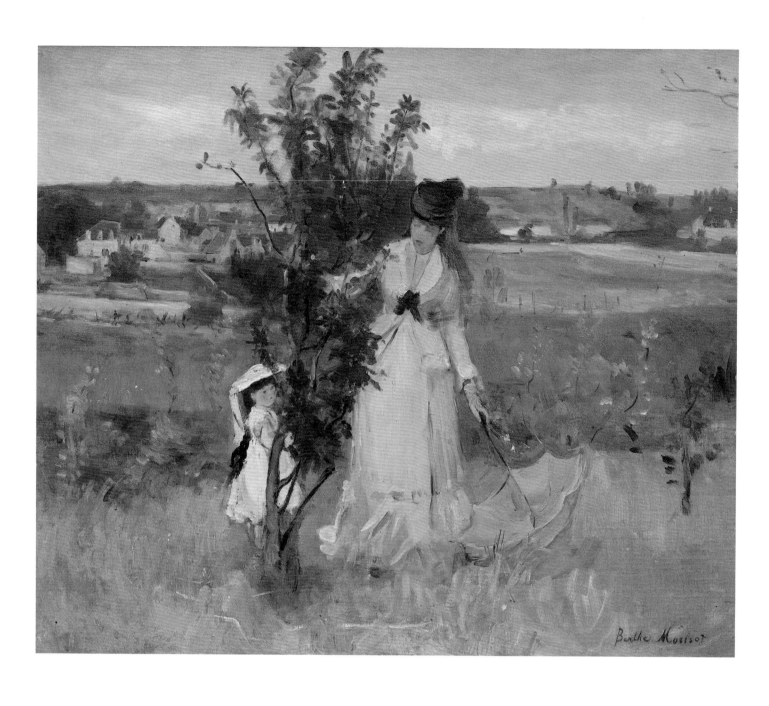

Berthe Morisot
1841-1895

17
Hide and Seek (Cache-Cache), 1873
oil on canvas, 17¾ x 21⅝ in.
signed in lower right corner: *Berthe Morisot*

This picture was painted on the property belonging to the artist's sister, Mme Pontillon, at Maurecourt. It seems that Manet—the artist's future brother-in-law—expressed great liking for this work and that she thereupon presented it to him. She subsequently asked him to lend it to the first group show of the impressionists in 1874.

Although the impressionists were greatly abused by the critics on the occasion of this historic exhibition, Castagnary, a friend of Courbet and for years a champion of work done from nature, wrote in a review: "Mlle Berthe Morisot has *esprit* down to her fingertips, especially in her fingertips. What delicate artistic feeling! One couldn't find more gracious pages, more deliberately and finely done than the *Berceau* [now in the Louvre] and *Cache-Cache*; I should like to add that here the execution is perfectly related to the idea expressed." (Castagnary, "Les Impressionnistes," *Le Siècle*, April 29, 1874.)

Camille Pissarro
1830-1903

18

The Artist's Daughter, Jeanne, 1872
oil on canvas, 28½ x 23½ in.
signed and dated in upper right corner:
C. Pissarro 1872
Yale University Art Gallery, John Hay
Whitney, B.A. 1926, Honorary M.A. 1956,
Collection

Pissarro painted few portraits and these were exclusively of members of his own family, of close friends, and of some peasants he knew well. Among these rare likenesses, the portrait of his little daughter Jeanne stands out, for it is the first "close-up" he did. The child was seven years old when he painted her, combining softness of color with a tenderness that makes one think of his former master, Corot. But over this portrait there hovers a slight note of sadness in the large, questioning eyes of the girl. It is as if Pissarro had a foreboding that Jeanne was to die only two years later.

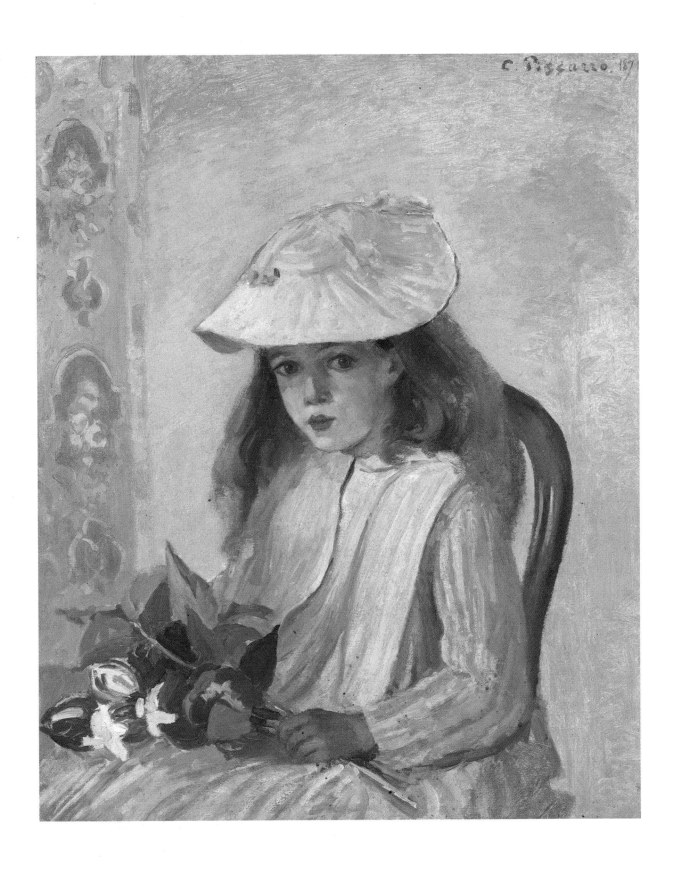

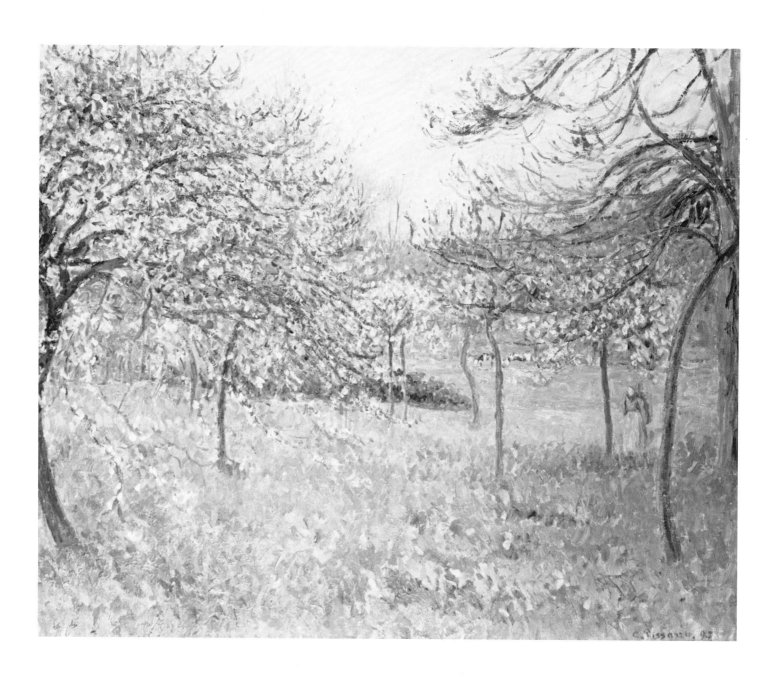

Camille Pissarro

19
Apple Trees in Blossom, Gray Weather at Eragny, 1897
oil on canvas, 23¾ x 29 in.
signed and dated in lower right corner:
C. Pissarro. 97

Early in 1897 Pissarro rented a hotel room in Paris and painted a magnificent series of urban scenes, of which the National Gallery's *Boulevard des Italiens Morning, Sunlight* is one. Upon returning to his house in the country at Eragny-sur-Epte, he continued a series of rural landscapes, as seen from behind a window in his studio. The trouble he was experiencing with his eyes was less severe when he was protected from drafts; he was able to paint the Whitney orchard scene and others, of gardens and fields, during all kinds of atmospheric conditions—rain, fog, morning sunlight, and afternoon sunlight.

It was while working on the early 1897 series that Pissarro explained how he proceeded, by giving the following advice to a young painter, Louis Le Bail: "The motif should be observed more for shapes and colors than for drawing. There is no need to tighten the form, which can be obtained without that. Precise drawing is dry and hampers the impression of the whole; it destroys all sensations. Do not insist on the outlines of objects, it is the brushstroke of the right value and color which should produce the drawing. In a mass, the greatest difficulty is not to establish a minute contour but to paint what is within.—Don't work bit by bit, but paint everything at once by placing tones everywhere. . . . The eye should not be fixed on a particular point but should take in everything, while simultaneously observing the reflections that the colors produce on their surroundings. Keep everything going on an equal basis; use small brushstrokes and try to put down your perceptions immediately. Do not proceed according to rules and principles, but paint what you observe and feel." In the Whitney landscape we see these concepts put into practice.

Auguste Renoir
1841-1919

20

The Ball at the Moulin de la Galette, 1876
oil on canvas, 31 x 44½ in.
signed and dated in lower right corner:
Renoir 76

Although the story of Renoir's famous composition, *The Ball at the Moulin de la Galette,* is comparatively well documented, there exists a certain amount of confusion concerning this work, or rather its preliminary study and its two versions.

The artist's friend, Georges Rivière, has described in great detail the then still simple and almost rural establishment near the top of the Montmartre hill, where residents of the neighborhood gathered to dance every Sunday afternoon. Renoir liked to come there frequently, particularly because he found there young models who had the advantage of not being professionals. According to Rivière, most of the girls who appeared in Renoir's paintings between 1875 and 1883 were recruited from among the habituées of the Moulin de la Galette.

In May 1876, Renoir conceived the idea of painting a large composition of the dancers at the Moulin de la Galette. If Rivière is to be trusted, he and his friends helped the artist every day to carry the large canvas from his nearby studio to the dancehall, where a number of friends posed for Renoir in the company of young women selected from among the customary Sunday crowds. Yet it is not certain which of the paintings representing the scene at the dancehall was actually executed on the spot.

A first sketchy canvas of the subject is now in the Ordrupgard Museum near Copenhagen. Of the two "final" versions of the painting, both dated 1876, the one in the Musée d'Orsay (Galerie du Jeu de Paume) is the larger. This suggests that it was the Whitney version which Renoir painted at the Moulin de la Galette, subsequently using it for the larger composition, executed in his studio. But regardless of which of the two versions preceded the other, they do not present slavish repetitions.

The main difference between the two paintings is that the Whitney picture is characterized by a more diffused light which bathes the entire canvas, softening the contours of the forms, whereas the Paris version shows a somewhat stronger insistence on outlines and volumes, with the result that the dancers and the seated figures in the right foreground are detached more sharply from their surroundings. It is as if Renoir had set himself two different problems while working on his composition, and had decided to solve them on two different canvases: one being a study of atmospheric conditions in the true impressionist spirit, the other attempting to portray more precisely the individuals in this lively open-air scene. This basic difference in the two versions might of course be taken to mean that the Whitney painting, more concerned with the vibrant play of lights and shadows which Renoir so frequently studied in those years, is actually the canvas painted on the spot.

It is generally assumed that it was the Paris version which Renoir exhibited at the third impressionist group show in 1877, though this cannot be proved with certainty. The catalogue merely lists under No. 186 *Bal du Moulin de la Galette*, without dimensions or indication of ownership, whereas *La Balançoire*, also painted in 1876, is given as belonging to M. C. [Caillebotte]. It could be argued that Caillebotte acquired the painting only *after* the closing of the show, particularly since he made it a rule to help his friends by preferably buying their "unsaleable" works.

The reviews of the exhibition did not devote much space to this important entry, but Georges Rivière who, for the duration of the show, founded with Renoir's help a small weekly, *L'Impressionniste*, extolled the work with whose elaboration he was particularly familiar. After describing its gay and sunny atmosphere, he proclaimed:

"Certainly, M. Renoir has a right to be proud of his *Bal*. Never has he been better inspired. It is a page of history, a precious monument of Parisian life depicted with rigorous exactness. Nobody be-

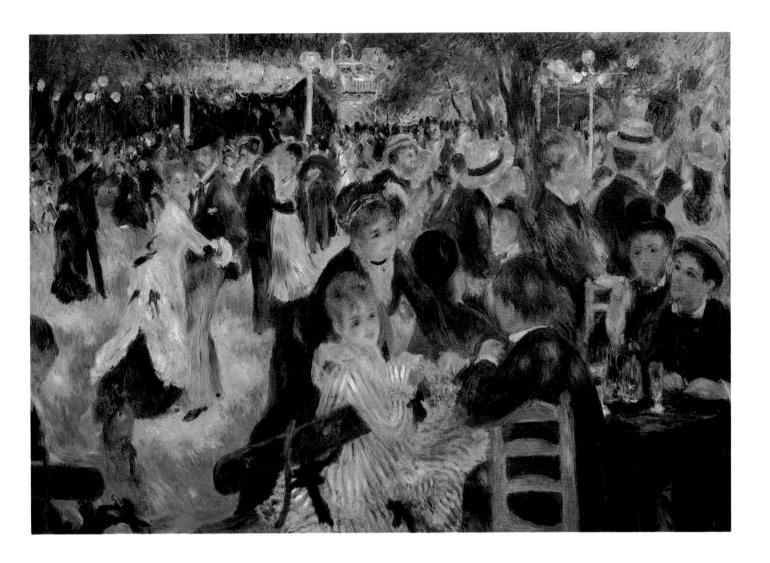

fore him had thought of capturing some aspect of daily life in a canvas of such large dimensions. This audacity will be rewarded by success, as it deserves to be. I am anxious to predict that this painting has a great future. . . . M. Renoir and his friends have understood that historical painting is not a more or less entertaining illustration of things past; they have opened a road which others will certainly follow. . . .

"To treat a subject in terms of colors and not for the subject itself, that is what distinguishes the impressionists from other artists. . . . It is precisely this research, this new way of approaching a subject which is the very personal quality of Renoir. . . . He has attempted to produce a contemporary note, and he has found it; the *Bal,* whose color has such charm and novelty, will certainly be the great success among the art exhibitions of this year."

Post-impressionism

Paul Cézanne
1839-1906

21

Still Life with Apples, Pears, and a Gray Jug, 1893-1894
oil on canvas, 23¼ x 28½ in.

In Cézanne's long, slow battle for recognition, his still lifes were the first works to find admirers. Their masterly composition, their color and their texture—either obtained through patiently accumulated brushstrokes or, as in this painting, through a thin layer of immaculate tones—gave them a simple majesty and intense harmony which convinced even the most hesitant. The artist sometimes worked on them for many months, since the subject lent itself to more sustained "poses" than any other, and—if necessary—used artificial flowers and fruit so as to have unlimited time at his disposal. How he assembled the elements for a still life has been described by a young painter, Louis Le Bail, who met Cézanne at Montgeroult and once watched him prepare such a composition:

"The cloth was draped a little over the table, with instinctive taste; then Cézanne arranged the fruit, contrasting the tones one against another, making the complementaries vibrate, the greens against the reds, the yellows against the blues, tilting, turning, balancing the fruit as he wanted it to be, using coins of one or two *sous* for the purpose. He took the greatest care over this task and many precautions; one guessed that it was a feast for the eye to him."

Cézanne later advised Emile Bernard "to treat nature by the cylinder, the sphere, the cone." His concern to ennoble and simplify his pictorial elements by reducing them to their basic forms was one of the aspects of his art which had most influence on the cubists, though, unlike them, he never allowed the underlying geometry to obtrude.

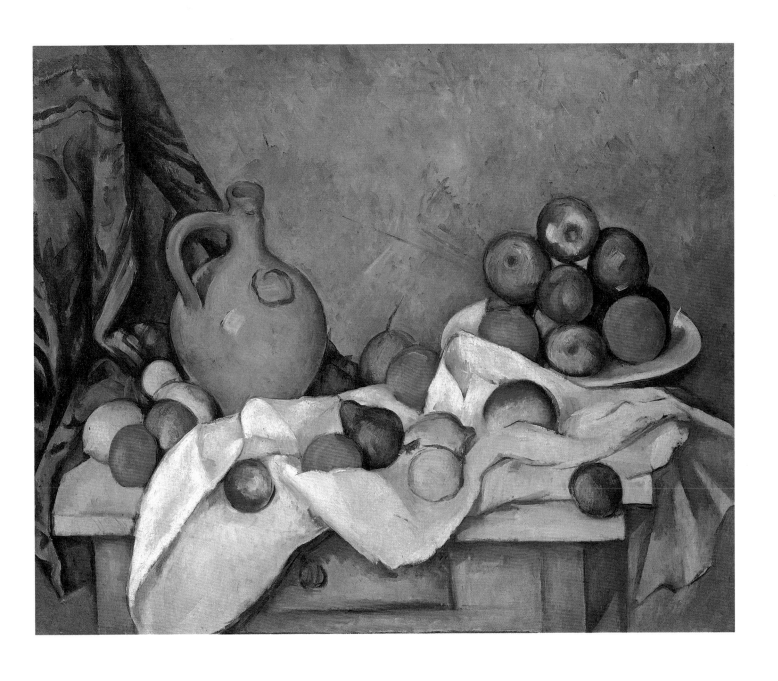

Paul Cézanne

22

Turning Road at Montgeroult, 1898
oil on canvas, 32 x 25⅝ in.

This is possibly the last important and completely finished landscape which Cézanne painted in the North before retiring more or less permanently to Aix. Montgeroult is a village near Pontoise (where Cézanne had previously worked in the company of Pissarro); he stayed there during the summer of 1898—not 1899 as frequently stated—and was often visited by the young painter Louis Le Bail. The subject is a turning uphill road and not a river, as stated by Venturi.

Meyer Schapiro has described the painting as follows: "It is an undistinguished subject, without a dominant or a central point of interest, yet is picturesque for modern eyes. The Romantics found the picturesque in the irregular, the roughly and oddly textured, the ruined, the shadowy and mysterious; the painters of the beginning of this century found picturesque the geometric intricately grouped, the disorder of regular elements, the decided thrust and counterthrust of close-packed lines and masses in the landscape. A scene like this one was fascinating to the artist as a problem of arrangement—how to extract an order from the maze of bulky forms. It is one aspect of the proto-Cubist in Cézanne.

"Here the severely geometrical is crossed with the shapeless, pulsing organic, its true opposite. The yellow road, cutting through the foreground vegetation, carries the angular thrusts of the buildings into the region of growth. In contrast to the solid, illuminated substance of the thickly painted buildings, rendered with dark outlines, the bushes and trees rise among them in loose masses of thin, cool color. There are similar tones in the roofs and shaded walls, but these are strictly bounded by drawn lines, unlike the edges of the bushes and trees. To the bareness of the bright, hot surfaces of the houses is opposed the polychromy and more impulsive brushwork of the darker foreground." (M. Schapiro, *Cézanne* [New York, 1952], 112.)

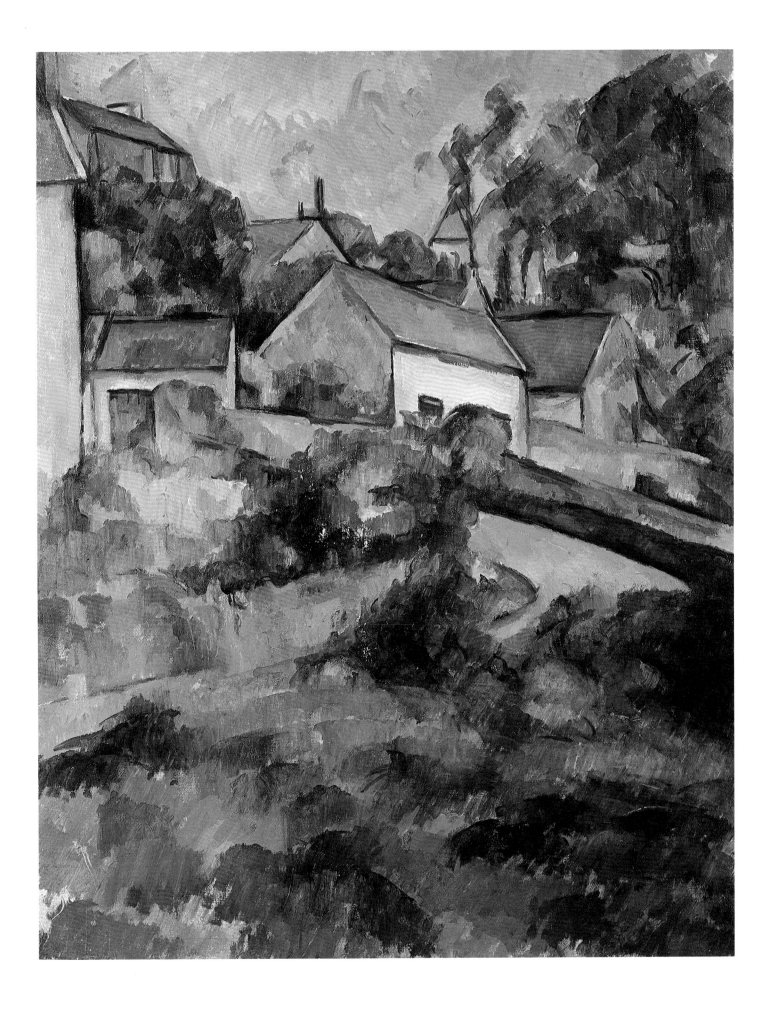

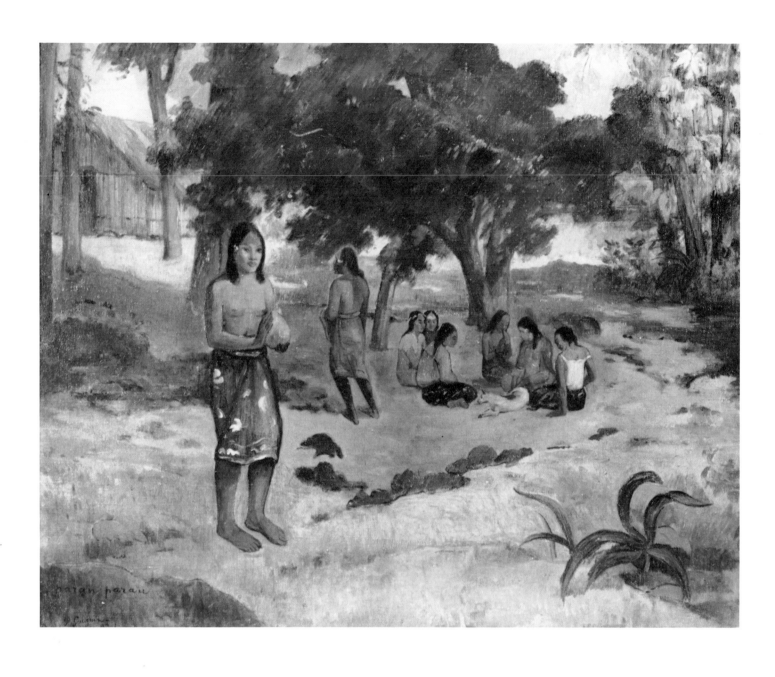

Paul Gauguin
1848-1903

23
Parau Parau -Conversation, 1892
oil on canvas, 30 x 37¾ in.
signed and dated in lower left corner:
P. Gauguin 92, with inscription above the
signature: *parau parau*
Yale University Art Gallery, John Hay
Whitney, B.A. 1926, Honorary M.A. 1956,
Collection

In 1891 Gauguin painted a group of squatting Ta-hitian women. The next year he included several figures from this group in another painting, *Parau Parau*, in which, however, the emphasis is no longer on these women but on the luxuriant tropical landscape with, in the foreground, a standing Tahitian girl whose attitude is closely related to that of the two angels in his famous *Ia Orana Maria*, also painted in 1891. Such repetitions and borrowings from his own previous canvases are quite frequent in Gauguin's work (they have been pointed out by J. Rewald, *Gauguin Drawings*, New York–London, 1958).

Among the many notes on his life and work which Gauguin jotted down, there is a passage that seems to have been written almost specifically for this canvas, though it treats of his exotic art in general:

"As I want to suggest an exuberant and wild nature and a tropical sun which sets on fire every-thing around it, I have to give my figures an appropriate setting. It really is open-air life, although intimate; in the thickets and the shadowy brooks, those whispering women in an immense palace decorated by nature itself with all the riches that Tahiti holds. Hence these fabulous colors and this fiery, yet softened and silent air.

"But all this does not exist!—Yes, it exists as the equivalent of the grandeur and profundity of this mystery of Tahiti, when it must be expressed on a canvas three feet square.

"She is very subtle and very clever in her *naïveté*, the Tahitian Eve. The enigma hidden in the depths of her childlike eyes remains incommunicable. Like Eve's, her body is still that of an animal, but her head has progressed with evolution, her mind has developed subtlety, love has imprinted an ironical smile upon her lips, and naïvely she searches in her memory for the *why* of present times. Enigmatically she looks at you."

Vincent van Gogh
1853-1890

24
Olive Trees, Saint-Rémy, June 1889
oil on canvas, 28½ x 30¼ in.

On May 8, 1889, van Gogh arrived from Arles at nearby Saint-Rémy for his voluntary internment in the asylum there. This ancient institution lies in a fertile plain and is surrounded by fields of wheat, vineyards and olive groves; toward the south it is close to the rugged mountains which appear in this painting, last chain of the distant Alps. On June 19 the artist reported to his brother:

"I did a landscape with olive trees [probably the present picture] and also a new study of a starry sky. . . . When you have had these two studies before you for a certain time . . . then I may be able to give you a better idea than through words of the things that Gauguin, Bernard, and I have sometimes discussed and that preoccupy us. This is not a return to the romantic or to religious ideas, no. Nevertheless, while deriving from Delacroix more than might appear, in color and through a draftsmanship that is more intentional than the exactness of *trompe l'oeil*, one can express a rustic nature that is purer than the suburbs . . . of Paris." (Vincent van Gogh, *Verzamelde Brieven* [Amsterdam, 1953], 3, 432.)

Only after recovering from his first severe seizure in July did he send them to his brother, together with a letter in which he tried to explain once more why he had departed from the direct observation of nature and let his imagination invent forms and colors—or at least exaggerate them—in order to create a specific mood.

"The olive trees with the white cloud and the mountains behind," he wrote, "as well as the rise of the moon and the night effect, are exaggerations from the point of view of the general arrangement; the outlines are accentuated as in some of the old woodcuts." And later on in the same letter he specified: "Where these lines are tight and purposeful, there begins the picture, even if it is exaggerated. This is a little bit what Bernard and Gauguin feel. They do not care at all

about the exact form of a tree, but they do insist that one should be able to say whether its form is round or square—and, by God, they are right, exasperated as they are by the photographic and silly perfection of some painters. They won't ask for the exact color of mountains, but they will say: 'Damn it, those mountains, were they blue? Well then, make them blue and don't tell me that it was a blue a little bit like this or a little bit like that. They were blue, weren't they? Good—make them blue and that's all!'" (van Gogh, *Verzamelde Brieven*, 3, 463-464.)

As soon as the pictures arrived in Paris, Théo told his brother: "I do understand what interests you in the new paintings, such as the village in the moonlight [*Starry night*] or in the mountains, but I find that the search for style detracts from the real feeling for things." (van Gogh, *Verzamelde Brieven*, 4, 277.)

Today, however, it is precisely this "search for style" which seems van Gogh's major contribution. As Alfred Barr has written on the subject of *Starry Night*, companion-piece of *Olive Trees*: "Its style marks a turning point in his art. . . . The struggle, internal and external, which involved the picture throws a clear light upon one of the fundamental conflicts which have engaged the artists of the past hundred years. This is the conflict between fact and feeling, between prose and poetry, between realism and imaginative vision. . . . It was in the Saint-Rémy pictures with their flamboyant cypresses, twisted olive trees and heaving mountains that van Gogh was finally able to free his art from the objective realistic vision of the impressionists. The surging lines not only bind the composition into active rhythmic unity—they express magnificently the vehemence and passion of van Gogh's spirit." (Alfred H. Barr, Jr., *Masters of Modern Art* [New York, 1954], 26 and 28.)

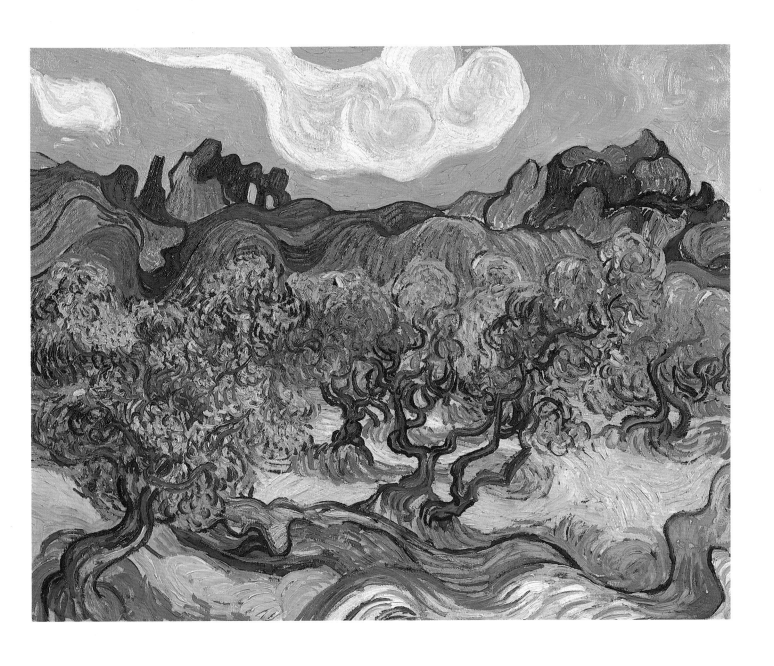

Vincent van Gogh

25

Self-Portrait, Saint-Rémy, September 1889
oil on canvas, 22½ x 17¼ in.

Early in July 1889, Vincent van Gogh suffered his first attack at Saint-Rémy, while working in the fields near the asylum. For six weeks he was confined to his room. The first canvas he painted after his recovery was this self-portrait. The piercing gaze of his blue eyes seems to indicate determination rather than discouragement.

In September he wrote to Théo: "They say—and I gladly believe it—that it is difficult to know oneself, but it isn't easy to paint oneself either. For the time being I am working on two portraits of myself—since I have no other models—for it is high time for me to paint some figures. One of them I started the first day I got up; I was thin and pale like a ghost. It is dark blue-violet, the head whitish with yellow hair, in other words an effect of color [contrasts]." (van Gogh, *Verzamelde Brieven*, 3, 449-450.)

Meyer Schapiro has analyzed this painting—one of the artist's most powerful and haunting self-portraits—in the following words: "The pervading blue, warmer, more violet, in the background, cooler in the clothes, shapes a mood that we cannot name or easily approximate in words, but of which the inward-pointing nature is clear. Not only is the blueness shared by the costume and the 'abstract' surroundings, but the live brushwork forming this environment follows in its interwoven traces the changing edges of the head like a halo around it; at the same time it conforms in its vehement flow to the impassioned rhythms of the strokes that model the costume and the hair. Out of the dark hollow in the center of this blue emerges the head with a glowing intensity. . . . The face is mostly in shadow, a beautifully painted transparent shadow, rich in greens and blues, a dark film through which peer the red-rimmed eyes, probing and sad. . . . This portrait in its jeweled perfection and depth of feeling permits us to measure van Gogh's great advance since the last of his Paris portraits; it corresponds to a deeper self-insight as well as to an enormous growth in power of expression." (M. Schapiro, *van Gogh* [New York, 1950], 103.)

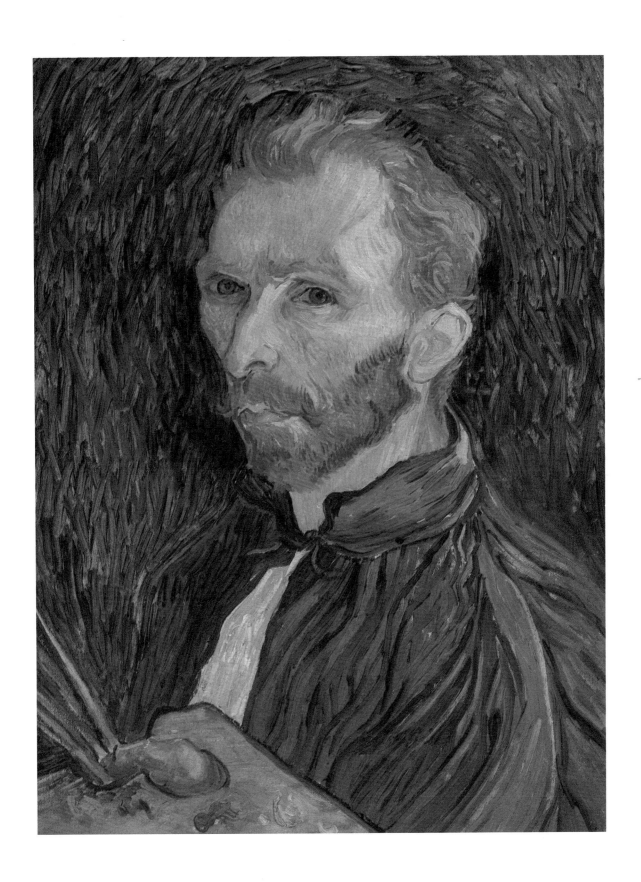

Odilon Redon
1840-1916

26
Flowers in a Green Vase, c. 1910
oil on canvas, 21½ x 29¼ in.
signed in lower left corner: *ODILON REDON*

Only a poet, it would seem, could undertake to describe a still life of flowers by Redon. Yet the poets who were his friends—Mallarmé, Huysmans, and Verhaeren foremost among them—were attracted mainly by his evocative and mysterious drawings and lithographs which lend themselves so admirably to interpretations and dreams. It is true, however, that Mallarmé died before Redon definitely abandoned the disquieting world of his works in black and white and embarked, at an advanced age, upon the rediscovery of color for which flowers afforded the finest opportunities.

Around 1890 the artist began to use pastels and oils; the former a new medium for him, the latter one which he had neglected for many years. Most of his paintings were at first of a contemplative and mystical nature, a reflection of the peace and happiness that had only recently descended upon him. After the death of a first son in infancy, a second was born in 1889 and lived. At the same time Redon's work slowly began to gain the admiration if not of a large public at least of a select few: adherents of the symbolist movement in literature and a new generation of painters, including the group of young Nabis. In the middle nineties there occurred a new crisis when family conflicts

and financial reverses led to the sale of his father's estate near Bordeaux where Redon had grown up and to which he had a strong emotional attachment. But once he had overcome his profound depression, he threw himself into his work with renewed energy; rather than revert to the haunting atmosphere of his drawings he explored the fascination of color.

Redon began to spend his summers near Royan, north of Bordeaux, where he worked with fervor, particularly on rainy days. "At the end of the season," his son reports, "the walls of his studio were covered with pastels and paintings of flowers: the large white-washed room had become a real greenhouse with luxuriant vegetation."

In 1910 his wife inherited a beautiful country house not far from Paris with a large garden where the artist could cultivate flowers. His complete happiness dates from that time. "In my new home I enjoy so much felicity," he wrote to friends, "that I must abstain from telling you about it; the subject is inexhaustible." It was at that time and in this frame of mind that Redon painted his finest flower pieces. According to the artist's son the still life of *Flowers in a Green Vase* falls precisely into this period.

Henri Rousseau, called Le Douanier
1844-1910

27
L'Heureux Quatuor (The Happy Quartet),
1902
oil on canvas, 37 x 22½ in.
signed in lower right corner: *H. Rousseau*

Quietly and in his own way Henri Rousseau elaborated a new style. Its main feature was perfect naïveté. While the general public laughed at his clumsiness, Pissarro and Gauguin appreciated Rousseau's painterly qualities, and eventually a group of poets, artists, and friends of Picasso feted the old man with a mixture of affection, admiration, and amusement. A German philosopher, Otto Pfister, tried to explain the importance of Rousseau in the eyes of many young artists:

"For a long time aesthetic has demanded that a work of art be not the result of clever calculations but the product of a higher inspiration. Not consciousness, but the unconscious is the real womb in which all great art is born. That is why the artistic idea appears to man like a miracle, a revelation, whereas intent plays only an indirect role. When it is least expected, the longed-for image presents itself before its creator. . . . Where this creative directness, this eruption from the unconscious is lacking, there is no question of true art. . . ."

But is the unconscious really a dominant factor in Rousseau's art? The painstaking application with which he executed his pictures, the "perfected" naïveté with which he strove to give form to his dreams or his observations of nature seem to belie such an interpretation. Robert Goldwater has justly pointed out that Rousseau might have painted perfectly academic nudes or compositions, had he only known how. What saved him from platitude was precisely his childlike mentality and a hand which, in spite of his desire for smooth perfection, only hesitatingly followed the dictate of the artist's perceptions or inventions. And here lies the charm of his work, in the fact that there always remains a cleft between intention and realization.

The subject of *Heureux Quatuor*, this image of paradise with musical overtones, might have lent itself to an atrociously vulgar picture but for the grace of Rousseau's genius. The poetry with which he was able to infuse this scene of his dreams and the very shortcomings of his draftsmanship, relieved by an exquisite feeling for color, here combine to create an image of touching beauty.

Henri Rousseau

28
Tropical Forest with Monkeys, 1910
oil on canvas, 51 x 64 in.
signed in lower right corner: *Henri
Rousseau/1910*
National Gallery of Art, The John Hay
Whitney Collection, 1982

Although Rousseau did serve in the French army, as member of a military band, during the years when an expeditionary force was engaged in the unfortunate venture that led to the short-lived Mexican Empire, there is every reason to believe that he never left France. But the fact that he did not see any tropical vegetation except in the Paris botanical gardens does not of course detract from the haunting qualities of his exotic paintings. Toward the end of the nineteenth century, the French government was making great propaganda efforts to develop its overseas possessions. Simultaneously, Pierre Loti's novels were widely read, various World's Fairs featured colonial pavilions, and newspapers published alluring reports. There was enough to inflame the imagination of a man who found in his art the only solace from a dreary life and who obviously discovered in tropical subjects a particularly suitable means of evasion from his surroundings. The very year Rousseau painted his first exotic picture was also the year in which Gauguin "escaped" to Tahiti.

We know now that Rousseau's tropical vegetation and fauna, are actually the product of his fertile imagination. But where is the harm? The Occident, which has always liked to dream of exotic paradises, readily accepted the enchanting world invented by Gauguin. The one represented by Rousseau is just as "real" as that of Gauguin. It is characterized by luscious colors and neatly assembled forms, by exquisite shapes of blossoms, leaves, branches, or foliage which, repeated throughout his compositions, create rhythms of great beauty, suggesting luxuriant plant life. There is no trace of the clumsy draftsmanship which lends so many of Rousseau's works their awkward and naïve charm. In tropical landscapes such as this, the painter, liberated from the necessity or the desire for verisimilitude, followed his inspiration to reach truth on a higher level, the truth of grandiose dreams which artistic realization endows with a new reality.

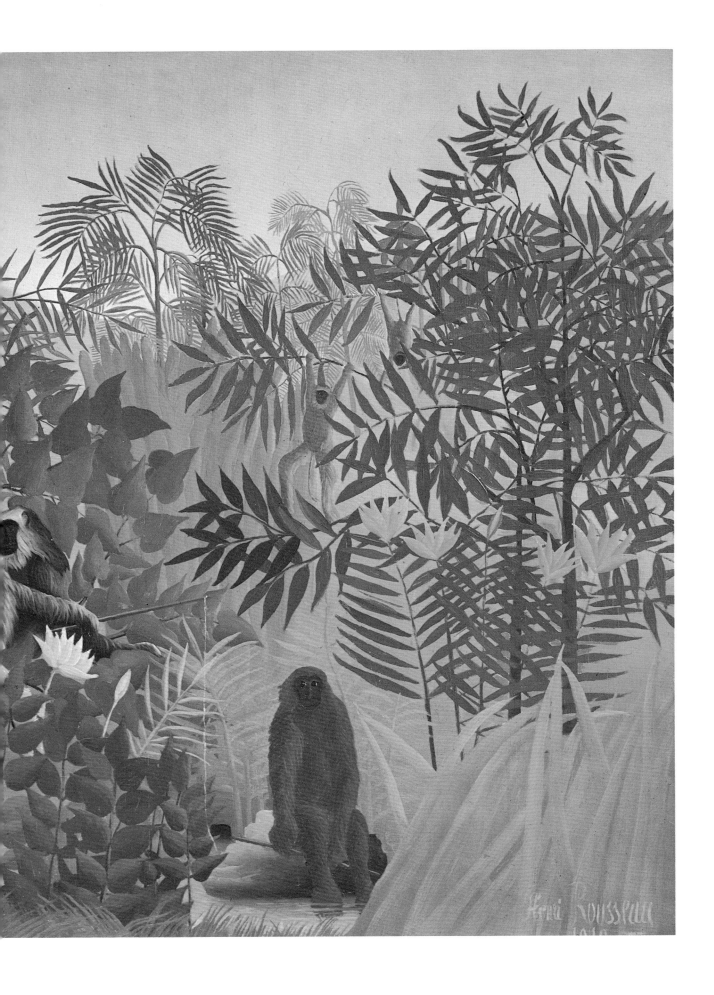

Henri de Toulouse-Lautrec
1864-1901

29

Marcelle Lender Dancing the Bolero in "Chilpéric," 1895-1896
oil on canvas, 57⅛ x 59 in.
red monogram of Lautrec estate in lower
left corner

Chilpéric, an operetta by Hervé, was revived at the Paris Théâtre des Variétés in February 1895. According to his friend Joyant, Lautrec spent many evenings "crouched in an orchestra seat, each time sketching at the same moment the demeanor of Marcelle Lender dancing the boléro." (M. Joyant, *Henri de Toulouse-Lautrec* [Paris, 1926], 1, 199.) The principal figures around her were famous actors of the time: Lassouche, Vauthier, Brasseur fils, Baron, Amélie Diéterle, and Simon. The scene depicted shows Brasseur, as King Chilpéric (a French monarch of the eighth century) watching with his entourage his Spanish bride, Galswintha, perform a boléro, one of the two choreographic numbers in which Mlle Lender appeared in this *opéra-bouffe.* The setting is a parody of a medieval court.

Marcelle Lender achieved a tremendous success in *Chilpéric*. She had first attracted the artist's attention when she appeared in 1893 in the fantasia *Madame Satan*; he had drawn three lithographs of her. From the innumerable sketches he made during the revival of *Chilpéric*, Lautrec derived not only the elements for this composition—the largest executed during his last years—but also material for six lithographic portraits. One of these shows the actress from the back. Lautrec's friend Romain Coolus, whom the artist invited some twenty times to accompany him to presentations of *Chilpéric*, reported that, "a little tired of listening night after night to the celebrated chorus, he asked Lautrec one day why he insisted on filling his ears with that tune. 'I only come to watch Lender's back,' he replied. 'Look at it carefully, for you will never see anything so magnificent.'" (R. Coolus, "Souvenirs sur Toulouse-Lautrec," *L'Amour de l'Art,* April 1931.)

Her back as well as her charm, her elegance, her vivacity, and the lithe grace of her body earned Marcelle Lender a prominent place in Lautrec's collection of inspiring models. She thus joined such picturesque figures as Yvette Guilbert, Jane Avril, May Belfort, and La Goulue. All these young women appealed to him not so much by their beauty (Yvette Guilbert was far from pretty and Marcelle Lender's finely drawn features were more interesting than lovely) as by their personalities, their gestures, their professional accomplishments, and the way in which they projected themselves in their performances.

The great attraction which the world of the stage and of make-believe (even of make-believe love) exerted on Lautrec can be explained partly as an escape from everyday life in which to many he was merely an amusing and ugly dwarf, and partly also by the fact that this artificial world exaggerates of necessity all essential traits. The brilliant stage light accentuates colors, movements, and expressions, often lending them a caricatural intensity. In addition, the farcical libretto of *Chilpéric* provided a welcome opportunity for the satirist to combine his astonishing gifts of observation with his *esprit*, blending them in a composition of unusual verve and vitality.

The flying pink skirts of the actress, their color echoed by the large flowers in her reddish hair, are set against the flat surface of the boards with only a whimsical, black-stockinged leg projected toward the onlooker. In contrast, the space behind her is crowded with figures and props, most of them kept in dark or low colors so as not to interfere with the *éclat* of the dancer.

Yet the two pages in blue achieve a certain prominence which prevents the background from being merely a foil for her; they also link her with the massive figure of the torero at the right, whose bulk balances the composition. The dramatically lit face of this man, which appears almost like a mask, directs an amused stare toward Marcelle Lender's slender foot (unless he contemplates her fascinating back) and thus skillfully ties the scene together. His counterpart to the left, the open-mouthed king, also looks at the swirling dancer.

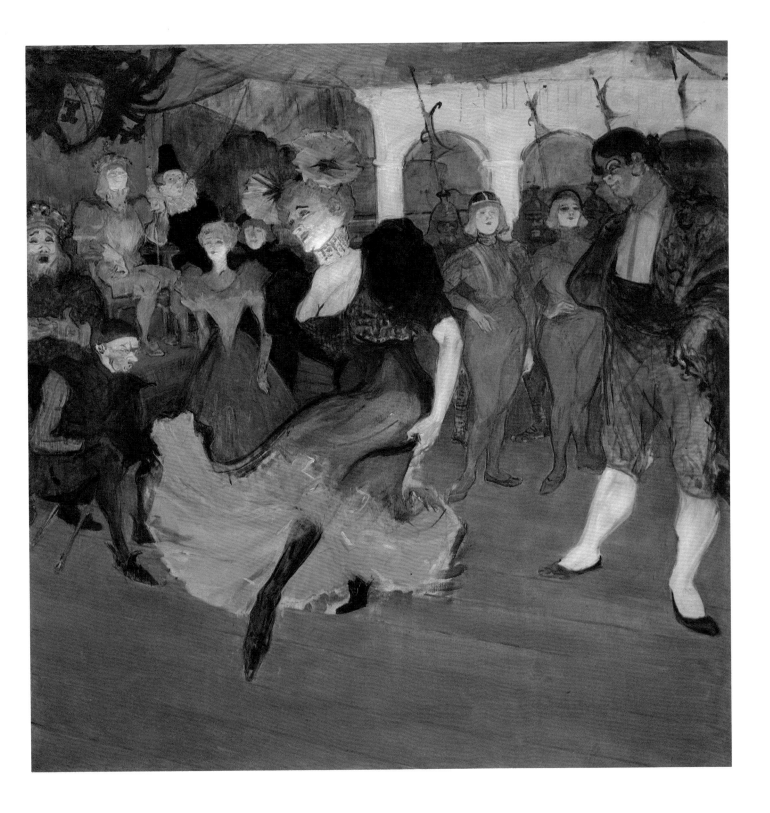

In the midst of the passive background figures, the heads of the king, the dancer, and the torero provide the basis for an upturned triangle whose point is constituted by the dancer's black-shoed toes.

This painting is more than a witty and dynamic interpretation of a theatrical subject; it seems in some ways to embody the spirit, the color, the unconcern, and the fun of the celebrated gay nineties, a period which found in Lautrec the very man to record not only what he saw but also what he enjoyed tremendously.

Maurice Utrillo
1883-1955

30
The Rue des Abbesses, Montmartre, c. 1910
oil on composition board, 30⅜ x 41¼ in.
signed in lower left corner: *Maurice Utrillo. V.*
Museum of Modern Art, New York, Estate of John Hay Whitney, 1983

Montmartre has changed a good deal since Renoir painted at the Moulin de la Galette, since van Gogh lived on the rue Lepic, and since Seurat worked during the last year of his short life in a small, hidden house within a stone's throw from the church of Saint Jean. But the new structures which were erected on its top and slopes, among them the basilica of Sacré-Coeur, were to provide Utrillo with an unending series of motifs. Since his day the now famous scenery has scarcely been altered.

The rue des Abbesses is still much the same and the grotesque church of Saint Jean still stands, its red brick tower of an undefinable Moorish-Gothic style arrogantly indenting the sky over huddled, old roofs. That Utrillo should have been able to integrate this architectural monstrosity into a balanced composition, distinguished by rich substance, rough textures, and a somber yet intense palette, is one of the marvels of his early and particularly creative years. But then his genius consisted precisely in giving a painterly treatment to the most thankless subjects, in infusing old and decrepit walls with a life and poetry all their own.

Edouard Vuillard
1868-1940

31
An Artist, c. 1893
oil on cradled panel, 14 x 9⅝ in.
signed in lower left corner: *E. Vuillard*

In 1890, at the age of nineteen, Paul Valéry analyzed in a letter to a friend the "secret of the strange and magnificent work" of Mallarmé whom he admired more than any other contemporary. The words he used to characterize his idol could equally well be applied to Vuillard:

"In long hours of solitude, in the pure contemplation of impossible visions, this timid mind has sharpened, has discovered the mysterious meaning of things and through this has expressed them. . . . His style is the very essence of that which he describes, the invisible web of distant relationships. . . ."

Some years later, Signac was to say that Vuillard "has a perfect understanding of the inner voices of things." Indeed, in an abundant production of usually small paintings—many of which remained in his studio until after his death—Vuillard explored the charm of his unprepossessing surroundings and derived from them unsuspected patterns and forms, harmonies and contrasts. Claude Roger-Marx has aptly described Vuillard's work of those early years of which *The Artist* is both a typical and a delightful example:

"At the height of Symbolism, he remained—like Bonnard, and even more than he—attached to the ordinary, to the things of everyday; far from losing himself in imprecision, vagueness, or instability, he limited his horizon, cloistered himself within his four walls. A painter of the intimate, he went back, as if it was being done for a wager, to the inconsiderable subjects which were despised because so many mediocrities had made a 'specialty' of them. But he approached these subjects with such strong concentration and tension, with such sustained emotion, with such detachment, with such respect for the object loved and rediscovered, with such contempt for artifice, that . . . he quite naturally perceived mystery and silence in reach of his hand, his heart, and his memory. It is through this feeling for the mysterious in everyday life that he held communion with his time and succeeded in making it accept and love a semblance of realism which it would otherwise have condemned." (C. Roger-Marx, *Vuillard et son temps* [Paris, 1946], 17.)

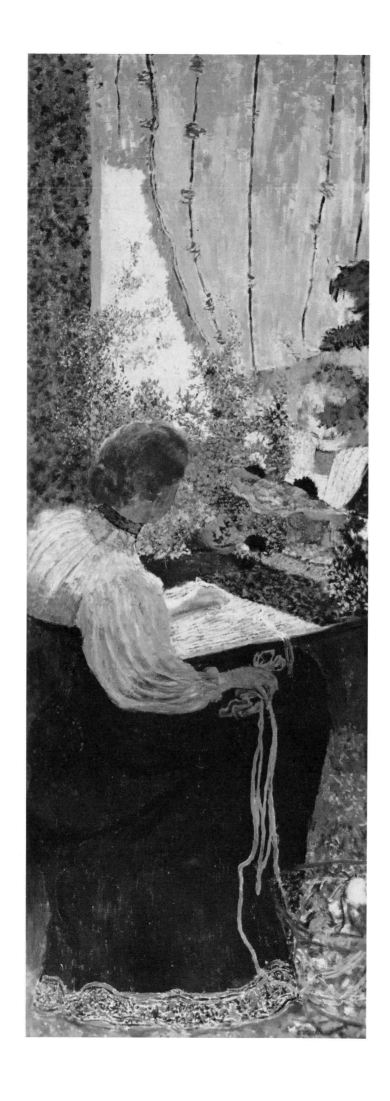

Edouard Vuillard

32
Embroiderers near a Window (Tapestry),
1895-1896
oil on canvas, 69 ⅞ x 25 ⅞ in.
signed in lower right corner: *E. Vuillard*
Museum of Modern Art, New York, Estate
of John Hay Whitney, 1983

It is rare that an artist as opinionated as Signac renders homage to a fellow painter whose form of art is completely opposed to his own. Yet after meeting Vuillard early in 1898, Signac wrote in his diary:

"Vuillard takes me to his place. He is a subtle and intelligent fellow, a nervously sensitive and searching artist. One feels him impassioned by art and restless. He is also a man leading a dignified and respectable life. He lives with his mother, and in that small family apartment, far from the coteries, he works. He shows me all his studies of the various periods through which he has passed. His small notations of interiors have great charm. He has a perfect understanding of the inner voices of things. They are the work of a beautiful painter, these pictures of a mute chromatism in which there is always a colorful accent that regulates the harmony of the work. The contrast of tones, a masterly chiaroscuro, balances the various tints which, though lusterless and gray, are always rare and refined—almost sickly.

"Vuillard is evidently a painter completely liberated from the reality which oppresses us [the neo-impressionists]. In that balance which regulates the proportion of nature by which the artist must be inspired, he is on the side which inclines too much toward fantasy and not in the other direction. We are tied down by the need for reality while he, because of an excess of fantasy, has to be satisfied with small studies. . . . If he had to do large canvases, he would be forced to be more precise, and how could he manage that?"

But a few months later, when Vuillard took Signac and a friend of his to see some of his recent mural decorations, Signac readily changed his opinion of Vuillard's ability to cover extensive surfaces. In point of fact, Vuillard had, for several years, executed series of mostly narrow and tall panels not unlike the elongated shapes of Japa-

nese Kakemonos. These were usually conceived as decorations composed of several related panels and were commissioned by various collectors and friends. The present painting, however, does not seem to have belonged to any such group, nor does it appear to have been executed for any specific interior since—unlike Vuillard's decorative ensembles—it represents a scene from ·his mother's workshop. When Vuillard showed one of these groups to Signac, the latter noted in December 1898:

"Upon entering the room, we were struck by the harmony of his two panels. To be quite honest, until now, having known Vuillard's work only through bits of canvases or panels seen in the back rooms of art dealers, I could not appreciate his talent. I told him so: I didn't know him until today.

"What is especially noteworthy about these two panels is the clever way in which they fit into the decoration of the room. The painter took his key from the dominant colors of the furniture and the draperies, repeating them in his canvases and harmonizing them with their complementaries. . . . Truly, these panels do not look like paintings: it is as if all the colors of the materials and carpets had been concentrated here, in the corner of this wall, and been resolved into handsome shapes and perfect rhythms. From that viewpoint the work is absolutely successful, and it is the first time that I have received this impression from a modern interior."

Although, in his diary entry, Signac did not refer to this particular canvas, it can serve perfectly well to explain his enthusiasm. Its diffused light, its somber colors heightened by delicate accents, its conglomeration of small patterns opposed and balanced by dark masses, its undulating lines broken by blurred details, all these harmoniously assembled contrasts are merged into a work of serene beauty.

Edouard Vuillard

33
Portrait of the Artist's Mother, c. 1898
oil on canvas board, 13 x 14⅞ in.
signed in lower right corner: *E. Vuillard*

During his early years, while he was closely associated with his Nabi friends, Vuillard studied Gauguin's synthesist style, admired Japanese prints and listened to—rather than joined in—the heated discussions of the others, but at the same time he regularly withdrew into his own world to work in complete isolation. The only person who shared his quiet, almost hidden life was his mother. The profound affection which united mother and son until the former's death provided the painter with sentimental as well as material necessities. It permitted him to lead the discreet and sheltered existence to which he aspired; it also offered him, in his mother's dressmaker's shop, which was established in a room of their middle-class apartment, a host of subjects which he explored with steadily renewed curiosity and tenderness. Numerous are the works in which he represented his mother's two assistants bent on various tasks, even more numerous those in which he lovingly studied the features of the old lady, in the kitchen, at dinner, supervising a sewing girl, drinking coffee, talking to visitors, sweeping a room, feeding a grandchild, or simply resting.

In the beginning, Vuillard had been tempted by bold simplifications but later gradually showed himself more receptive to the delicate harmonies he constantly discovered in everyday surroundings. Toward the turn of the century, when the relationship among the various Nabis had become less close—though their friendships remained intact—Vuillard abandoned his interest in abstract arabesques and slowly turned to a more realistic treatment. The *Portrait of the Artist's Mother* excellently illustrates his changed attitude. While the decorative wallpaper is still an important feature, while the old lady's hair and her striped blouse are still rendered with the delicate concern for varied textures that was one of Vuillard's chief peculiarities, the face of the woman is softly modeled and, behind her head, a patch of wall covering, worn and rubbed, introduces an astonishing note of acute observation and realism.

So great was Vuillard's shyness, so strong his need for silence and freedom, that he never granted permission either to friends or to scholars to publish books on him and his work. He also left strict instructions that his diaries were not to be opened fewer than fifty years after his death. His pictures, however, provide us with a faithful record of his uneventful life, his emotions, and preoccupations, the things and beings he loved, the places where he lived or which he liked to visit. Among the many images which eloquently reflect his private world, this moving likeness of a mother observed by a devoted son is not only a tour de force in which penetrating characterization transcends an almost literal verisimilitude, it is also a milestone in the artist's evolution.

Neo-impressionism

Henri Edmond Cross
1856-1910

34
Coast near Antibes, 1891-1892
oil on canvas, 25⅝ x 36⅜ in.
signed bottom right: *henri Edmond Cross*
National Gallery of Art, The John Hay
Whitney Collection, 1982

Cross adapted the English translation of his family name, Delacroix, at the recommendation of his teacher Francois Bonvin. There were two reasons: desire to avoid comparison with the romantic master Eugène Delacroix and need to avoid further confusions with Henri-Eugène Delacroix, a now almost forgotten academic painter. Cross, a founding member of the Indépendants in 1884, did not fully employ neo-impressionist style until after Seurat's death in 1891. Following his delayed adoption of that style, he enthusiastically applied divisionist techniques in landscapes painted in his new home in the Midi.

The ostensible subject of *Coast near Antibes*, a rocky coastline, provides an uncluttered scene for Cross' exploration of its true subject, the effect of the all-pervasive sunlight. As it floods the landscape, the light is so strong that it bleaches color so that Cross' application of the principles of simultaneous contrast is difficult to find except in shadows. As a consequence, application takes on heightened importance. Cross' dots are almost identical in size and shape throughout the painting, and he arranged them in a compulsively regular grid. The immobility of all elements of the painting, signaled by the boats sitting completely out of the smooth water of low tide, is emphasized by the composition. Cross uses the uniformity of

a grid to affix the arbitrarily flattened shapes on the surface in a taut and compressed pattern of forms.

The schematic disposition of broken color across the surface makes looking at *Coast near Antibes* an experience which, for modern viewers, parallels looking too closely at a television screen. Although his facture is grounded in scientific theory and in spite of its regularity, it would be a mistake to infer that Cross used neo-impressionism mechanically, merely to convey particular visual information. Cross explained the process to his friend Théo van Rysselberghe: "Harmony implies sacrifices. We always proceed from an impression of nature. Well, relative to nature one cannot put everything on a canvas, and it isn't so much that one can't put everything, but that one can put only very little. These few things become everything—the work of the man. The sacrifices are of forms, of values, of colors, according to the thought which governs the work to be accomplished." (Cross to T. van Rysselberghe, no date, as cited in J. Rewald, *Post-Impressionism from van Gogh to Gauguin* [New York, 1962], 130, n. 73.) The spare, sun-filled vista of *Coast near Antibes* is invested with an ecstatic calm evocative of a symbolist atmosphere of mystery.

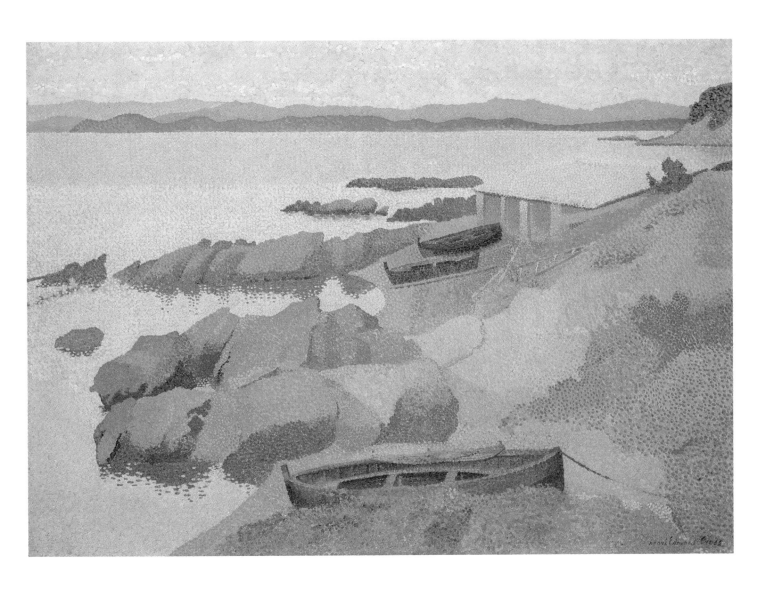

Henri Edmond Cross

35
The Grape Harvest, 1892
oil on canvas, 37 x 55 in.
signed and dated, bottom left: *henri*
Edmond Cross 1892

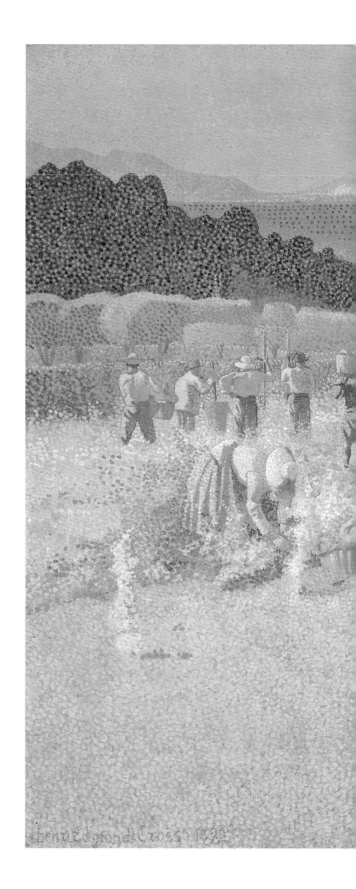

Like *Coast near Antibes*, *The Grape Harvest*, originally named *Vendages (Var)*, was painted while Cross still lived at Cabasson, his first permanent residence in the south of France. His arthritic limbs benefited from its warm climate, and its distinctive scenery, especially the rocky shore, verdant orchards, and vineyards which covered the hills, appealed to him. The primary motive for Cross' move from Paris was the brilliant sun, flooding the landscape and allowing the painter to concentrate on the study of light and color.

Cross believed neo-impressionist color theory was the ideal means to render his perceptions truthfully. Since such bright light absorbs color, he blended the pure pigments with white and, atop an initial layer of paint, placed the regular dots in almost uniform rows, avoiding violent effects with that modulation. Equivalences of tone and value are balanced to achieve the overall harmony he sought.

Another effect of the meridional sun is the reduction of detail to a minimum. Shapes are flattened and become integral decorative elements in the abstract design of Cross' composition. The profile of the interconnected empty baskets at the front mimics the rising and falling outline of the hills. Cross considered this conflict, the tension between observed phenomena and the abstract components of color and shape he employed to represent them, an absorbing problem of artistic discretion. Cross discussed this in his extensive correspondence, and on one occasion he wrote van Rysselburghe: "Should that be the goal of art, I ask myself, those fragments of nature arranged in a rectangle with more or less perfect taste? And I return to the idea of chromatic harmonies completely invented and established, so to speak, without reference to nature as a point of departure." (Cross to T. van Rysselberghe, c. 1902, quoted in M. Saint-Clair, *Galerie privée* [Paris, 1947], 33, footnote; cited in J. Rewald, *Post-Impressionism from van Gogh to Gauguin* [New York, 1962], 130, n. 74.)

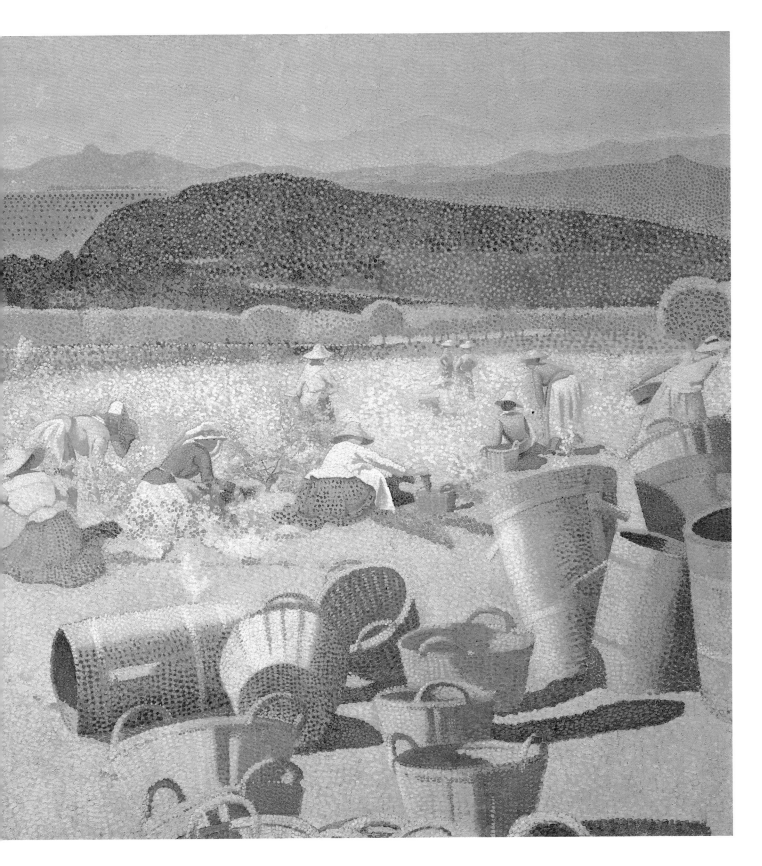

During 1892, Cross moved from Cabasson to Saint-Clair, another small town. Of the neo-impressionists, Paul Signac was particularly close to Cross; since Signac's home, Saint-Tropez, was relatively near Saint-Clair, the two painters were able to meet and exchange ideas about art. Together they transformed their styles, producing paintings characterized by lush colors applied in large, mosaiclike strokes. In the late 1890s and early 1900s, Matisse, Derain, and Marquet frequently visited Cross and Signac, and those visits became the primary source of the important neo-impressionist phase which preceded the development of fauvism.

Théo van Rysselberghe
1862-1926

36
The Harbor of Cette, 1892
oil on canvas, 21½ x 26 in.
Museum of Modern Art, New York, Estate
of John Hay Whitney, 1983

Van Rysselberghe's image of the crowded harbor at Cette, known since 1927 as Sète, depicts a view south across the outer basin toward the lighthouse and the tower of Fort Saint-Pierre on the Saint-Louis mole. It is probable that the artist visited Cette while en route to north Africa. Situated approximately midway between Marseilles and Collioure along the Mediterranean coast of France, Cette was next in importance and activity to Marseilles as a meridional port, and Sète has maintained this commercial prominence.

Rather than showing its brisk activity, however, van Rysselberghe presents a tranquil, almost static scene. Only three boats are in motion, two having just set out and the third being readied for embarkation, the diminutive sailors along the mast securing the unfurled sails. Permeated by bright light and a palpable atmosphere, characteristics for which van Rysselberghe was celebrated, the early morning calm is reinforced by his repeated use of stable horizontals and verticals in the composition, as lighthouse, tower, and masts rising above the boats' waterlines punctuate the horizon. In addition, his use of color and light, like that of the French neo-impressionists, further stabilizes the composition; the warm blond tonality of his light is balanced by cool blues in sky and sea, and the overall brightness is tempered by darker areas in the boats in the right foreground.

Théo van Rysselberghe was a founding member of the Belgian avant-garde group Les xx (Vingt), which was instrumental in the dissemination of French neo-impressionism to Belgium and the rest of Europe and England. Van Rysselberghe, often in Paris in the 1880s and 1890s, invited many French artists to exhibit in Belgium at the annual expositions of Les xx, starting in 1887 with *Le dimanche à La Grande Jatte* and other Seurat landscapes, and including works by his particular friends, Signac, Cross, and Luce. In return, he participated in several of the neo-impressionist dominated Indépendant exhibitions.

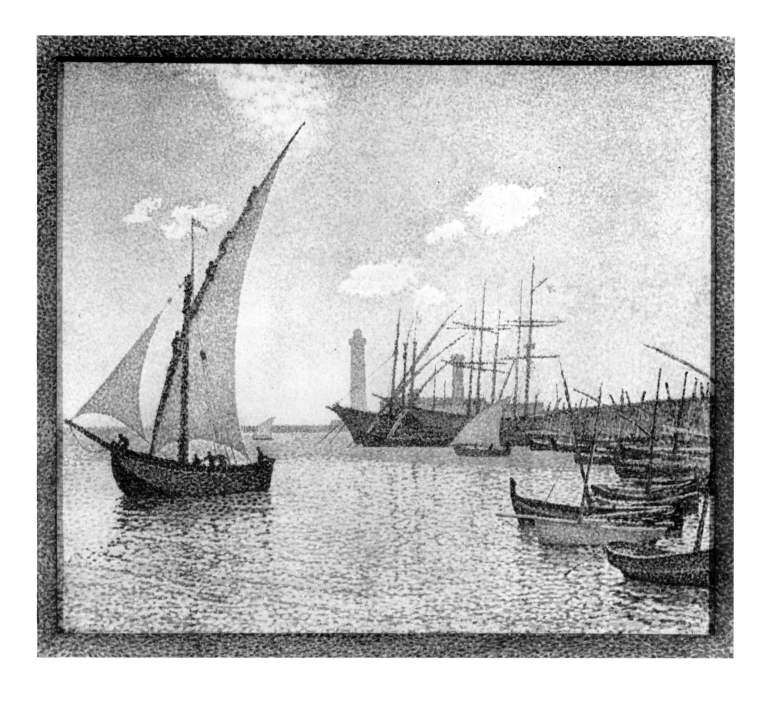

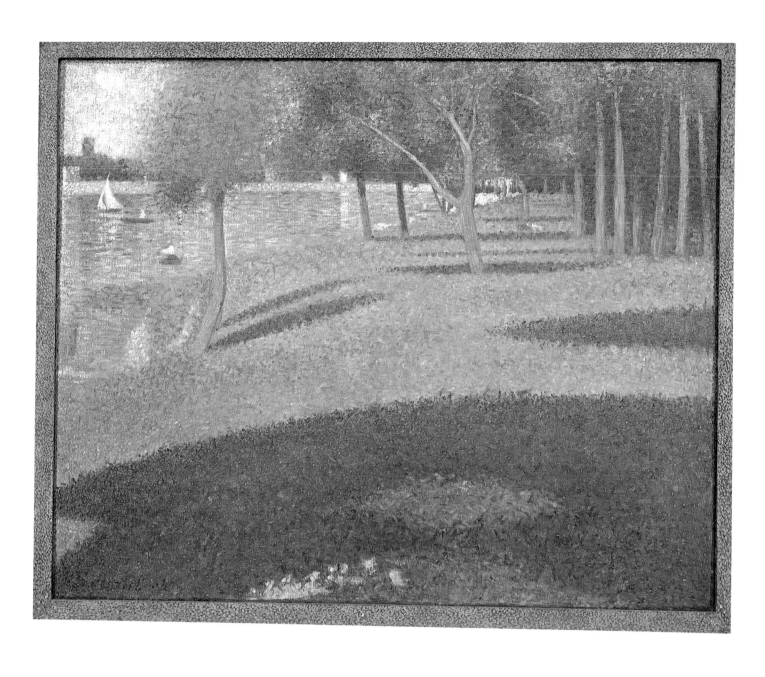

Georges Seurat
1859-1891

37
The Island of La Grande Jatte, 1884
(reworked at a later date)
oil on canvas, 27½ x 33¾ in.
signed and dated in lower left corner:
Seurat—84

First exhibited in December 1884, the painting was worked over again by the artist, probably in the autumn of 1885, when he also repainted the large composition, *Un dimanche à la Grande Jatte,* adding small dots over a more broadly brushed surface in order to obtain a better optical mixture. The signature and date were thus partly covered (which explains why the date appears to be 86 rather than 84).

According to a letter from the artist to Fénéon, written in June 1890, Seurat started to work simultaneously on the large canvas of *Un dimanche à la Grande Jatte* and on the preparatory studies in the spring of 1884; the exact date given by him is Ascension Day, 1884. The present landscape is, of course, not merely a preparatory study—most of these were done on small wooden panels—but an independent painting, except for the fact that it depicts the identical site and constitutes a major step toward the emergence of the large composition, which the artist obviously had in mind when he first put up his easel on the island of La Grande Jatte.

When this painting was exhibited in its initial state in 1884, Roger Marx, then the only critic to appreciate Seurat, mentioned the painter's "landscape of striking aerial transparency, over which the lively light of a hot summer sun plays freely; all this is done in a sincere and direct style and reveals depth of conviction. . . ." (R. Marx, "Les Indépendants," *Voltaire,* December 10, 1884).

Discussing Seurat's preparatory studies for *Un dimanche à la Grande Jatte,* Lord Kenneth Clark called this landscape ". . . the stage, so to speak, in which this drama of shapes is to be set—and it is a proof of how clearly Seurat worked out a composition in his mind that, although the final picture was not finished for two years, the original landscape, with all its apparent accidents of light and shade, was left practically unchanged. The only difference is an absence of emphatic verticals because, of course, he foresaw that these would be supplied by the figures."

The painted border on the canvas was added by the artist after the summer of 1889; the dotted frame is not by Seurat.

Georges Seurat

38
Grandcamp, Evening, 1885
oil on canvas, 26 x 32½ in.
signed and dated in lower-left corner:
Seurat 85; in the lower right: *Seurat*
Museum of Modern Art, New York, Estate
of John Hay Whitney, 1983

No other painter of the nineteenth century adhered so strictly to a set of theories as Seurat, and few painters in history actually allowed their theories to dominate their work to such an extent. Seurat was one of the few. One might almost say that he did not touch his brushes before he had made up his mind as to what he wanted, and that his concepts were established before he applied them to his work. Thus from the very beginning his evolution followed a line carefully planned by himself. The object of this evolution seems to have been the perfecting of a system, which then would automatically be reflected in the greater beauty of his canvases. The series of rules to which he adhered during his short life span was of such mathematical precision that the slightest infringement would have threatened to destroy the harmony of his paintings.

Seurat was barely twenty when he began, around 1878, to study systematically Chevreul's *Principles of Harmony and Contrast of Colors* as well as other theoretical treatises. He was fascinated by the idea that color is controlled by fixed laws which "can be taught like music." Among these laws was the one established by Chevreul, according to which "under the *simultaneous contrast of colors* are included all the modifications which differently colored objects appear to undergo in their physical composition, and in the height of tone of their respective colors, when seen simultaneously." One of the basic elements of this simultaneous contrast is the fact that two adjacent colors influence each other mutually, each imposing on its neighbor its own complementary (the light one becomes lighter, the dark one darker).

With his tiny brushstrokes in the form of dots, Seurat could accumulate on a small surface a great variety of colors or tones, each corresponding to one of the elements which contribute to the appearance of the colored object. At a certain distance—which varies according to the size of the dots chosen for the specific work—these tiny particles will fuse optically. And this optical mixture has the advantage of producing a far greater intensity than any mixture of pigments could do. *Grandcamp, Un Soir*, however, precedes by a few months Seurat's fully developed dot technique. In the sky and the sea, for example, we see short, horizontal brushstrokes, contrasted with the irregular specks of color in the land.

This work is one of a group of seascapes Seurat painted in the summer of 1885 at Grandcamp, a small fishing village on the Normandy coast; these paintings are low in tone, full of lyricism, and quite devoid of figures. Here, Seurat repeats the same strong diagonal used in *Bathing at Asnières* (1883/1884) but adds additional horizontals by means of a layered cloud effect.

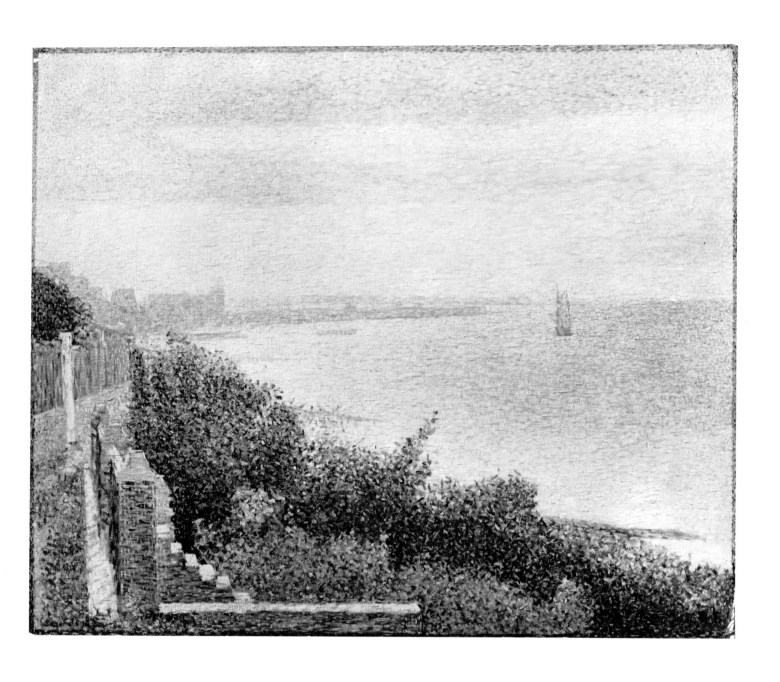

Paul Signac
1863-1935

39
The Yawl
oil on panel, 10 x 13¾ in.
signed bottom right: *P. Signac*

The Yawl was probably painted about 1886-1888 near the beginning of Signac's long career. The small panel is a rapidly executed sketch, analogous to Seurat's working sketches, and was made as an initial record of a motif, a picture he thought might be developed further. Even though no finished version of this particular motif is known, study of the panel reveals insights into Signac's working procedures not readily apparent in his finished paintings.

Signac was always an avid sailor and apparently was attracted by the visual possibilities seen from a captain's position behind the main mast of his boat. The view toward the stern which he selected allowed Signac to arrange a symmetrical, almost abstract, composition around the mizzenmast and horizon line, animating it with the diagonal and curving lines in the deck and rigging. Having chosen that view, Signac drew, then painted in, the broad lines of his composition, giving particular attention to the dark triangular mainsail coming in at the right to emphasize the horizon. Laying on the pointillist dots of color was the final step in the completion of this sketch.

Paul Signac

40
Fishing Boats in the Sunset, 1891
oil on canvas, 25 x 31½ in.
signed and dated bottom left: *P. Signac 91;*
inscribed at bottom right: *Op. 221*

Light from the setting sun in this painting casts intense yellow-orange radiance above and below the deep blue horizon. Signac complemented the warm colors with greens, blues, and purples in the sky and sea in accord with neo-impressionist practice. The two-masted fishing boats are almost identical, and even the tiny figures of fishermen rowing back to port are the same for each boat, resembling the stiff profiles in ancient Egyptian art which Signac deliberately evokes. Only slight variations of the boats' sizes and the intervals between them relieve the hieratic stillness of this monumental composition.

Fishing Boats in the Sunset is one in a series of five paintings first shown in the 1892 exhibition of Les XX. Signac titled the whole group *La Mer, les Barques, Concarneau 1891* and gave each painting a subtitle, in this case *Soleil couchant. Pêche à la sardine. Adagio.* All Signac's paintings in the series are seascapes executed at Concarneau, in Brittany, and Signac intended each to portray a specific musical concept using the purely pictorial vocabulary of neo-impressionism. Further, the group seen together was to form a symphonic sequence beginning with a scherzo movement and concluding with a presto. *Fishing Boats in the Sunset* was the fourth movement, a slow graceful adagio, and it succeeds magnificently. Music is suggested in the harmonious intervals of the composition. The boats make an even more pointed reference to music: their dark shapes, silhouetted against the bright red sun and concentrated near the horizon, resemble notes arranged on a musical score.

Fauvism

Georges Braque
1882-1963

41
The Harbor of La Ciotat, 1907
oil on canvas, 25½ x 31⅞ in.
signed with ink in lower right corner:
Braque

When, in the autumn of 1905, the fauve movement burst forth at the Paris Salon d'Automne, Braque was not among the painters gathered around Matisse. Somewhat younger than Matisse's friends and companions, Braque, in 1905, was particularly impressed by the work of Seurat (which Matisse had approached the year before through personal contact with Cross and Signac), as well as by Negro sculpture. He became a fauve in 1906 while working with Friesz at Antwerp, whence he went south to L'Estaque on the Mediteranean shore, following in the footsteps of Cézanne. The next year he spent the summer at La Ciotat, a few miles from Marseilles, where this picture was painted, and subsequently returned to L'Estaque; there he began to detach himself from fauvism. Braque's fauve period was thus a rather short one, a stepping stone in his evolution, though an extremely important one, since the artist himself felt, as he said, that he came at last into his own when he began to absorb fauvist principles.

Many of Braque's fauve paintings are fairly small. He seldom attained the violence of the others of the group and always remained more preoccupied with structure than most of them, thus preparing for his future works, his more restrained colors, and his insistence on logically developed forms. But in spite of his usually more delicate tonalities, Braque, during his fauve phase, reached the same exaltation as Matisse and Derain, the same happy balance of force and subtlety, of perception and expression.

Among Braque's fauve works this view of the harbor of the little southern fishing port of La Ciotat—a place as picturesque as Collioure—is exceptional on account of its size and importance.

André Derain
1880-1954

42
Mountains at Collioure, 1905
oil on canvas, 32 x 39½ in.
signed in lower left corner: *A Derain*
National Gallery of Art, The John Hay
Whitney Collection, 1982

The impact of van Gogh on the fauve movement was tremendous. Indeed, it was the first large exhibition of van Gogh's work, held in Paris in 1901, that became a decisive factor in the evolution of most of the future fauves. It was at this exhibition that Derain introduced his friend Vlaminck to Matisse who, as early as 1900, had begun to show in his works the first signs of the new style that was to be called fauve when it appeared in force in 1905.

During the summer of 1905 Derain worked with Matisse at Collioure, a small Mediterranean fishing port at the foot of the Pyrenees. Inspired by his friend's audacious transpositions and remembering van Gogh's forceful brushstrokes, his emotional use of pure colors, Derain completed in Collioure his evolution toward fauvism, begun at Chatou outside Paris in close communion with Vlaminck. He endeavored to exaggerate those features of nature which particularly struck him, to bring out their dominant character and, while so doing, to maintain the brilliant light, the high-keyed color throughout his entire canvas. Thus,

instead of a single striking note, his works—like all true fauve paintings—present in every part the same energy, the same vivid emotion, the same vigorous vision. Releasing his emotion with what appeared like frenzy, abandoning all adherence to local color, painting with rapid and decisive strokes, he simultaneously controlled his excitement and integrated the various components of his work.

In his *Mountains at Collioure* Derain contrasted the flat and more or less uniformly painted surfaces of the background (indebted to Gauguin, another forerunner of fauvism) with the lively short strokes in the foliage and grass of the foreground, thus increasing the tension created by the discordant colors. Yet such audacities were to him not an end in themselves. Wherever the eye roams over this canvas, it discovers happy invention, solid structure, and—beneath the powerful expression—a rare sensitivity which constantly tempers what otherwise might appear as a feat of sheer brutality.

André Derain

43
Charing Cross Bridge, London, 1905-1906
oil on canvas, 31⅝ x 39½ in.
signed in lower left: *Derain*
National Gallery of Art, The John Hay
Whitney Collection, 1982

Although Daniel-Henry Kahnweiler had taken an interest in the young Derain, Ambroise Vollard, on Matisse's advice, managed to purchase from the artist in February 1905 the entire contents of his studio at Chatou. Upon the painter's return from Collioure, where he had worked with Matisse, Vollard sent him to London and commissioned him to paint there a series of cityscapes, an idea plainly derived from the highly successful series of London views recently executed by Monet.

Derain approached the London vistas with the same imaginative eye that had guided his previous work. Many of these pictures show that the artist had meanwhile studied the works of Signac and his friends (as most of his fauve colleagues had done); he now combined an occasional pointillist execution and clashes of complementary colors with various features derived from the paintings of van Gogh.

Later on Derain explained: "Fauvism was our ordeal by fire. . . . Those were the years of photography. This may have influenced us, and

played a part in our reaction against anything resembling a snapshot of life. No matter how far we moved away from things, in order to observe them and transpose them at our leisure, it was never far enough. Colors became charges of dynamite. They were expected to discharge light. It was a fine idea, in its freshness; that everything could be raised above the real. It was serious too. With our flat tones we even preserved a concern for mass, giving for example to a spot of sand a heaviness it did not possess, so as to bring out the fluidity of the water, the lightness of the sky. . . . The great merit of this method was to free the picture from all imitative and conventional contact." (Quoted by D. Sutton, *André Derain* [London, 1959], 20-21.)

But shortly after the completion of his London series (the artist made two trips to London), Derain turned to Cézanne in the desire to dominate his passion and adopt a "more cautious attitude." His views of London are thus among the last of his fauve paintings which none of his later works have equalled in strength, invention, and color.

Kees van Dongen
1877-1968

44
Saida
oil on canvas, 25¾ x 21½ in.
signed in lower center: *van Dongen*

It had been assumed that this painting was either a fairly early one or possibly executed during the artist's trip to Egypt in 1913, but, according to a letter from the artist, the canvas was painted in Cairo around 1920.

With the exception of Matisse, van Dongen was the only fauve painter who remained a fauve for a considerable time instead of passing through fauvism as a more or less transient phase of his evolution. This makes the dating of his works comparatively difficult. In any case, the head of *Saida* can be considered a typical fauve painting with its exaggerated colors, strong contrasts, and dashing execution, a bold and exotic portrayal which, however, is·not devoid of subtlety and charm.

Raoul Dufy
1877-1953

45
The Beach at Sainte-Adresse, 1906
oil on canvas, 21¼ x 25⅝ in.
signed in ink lower left: *R. Dufy*

Greatly impressed with the works of Matisse and
Braque, Dufy—after working with Friesz, who
also hailed from Le Havre—abandoned his more
impressionist approach to nature and adopted
fauvism. But even then he usually showed a pref-
erence for more tender colors than those used by
the others, while developing a particular interest
in linear designs. In 1906 he worked in Le Havre
and its surroundings, such as the resort of Sainte-
Adresse, in the company of Marquet who seems
to have bolstered his audacity.

Flags and sailing boats became a trademark of
Dufy's fauve period, as well as crowds on beaches.
In his pictures prevails a gay mood as opposed to
the more dramatic aspects of Derain's or Vla-
minck's work of those days. The accentuated out-
lines of his figures were to lead to the more deco-
rative style of his later paintings.

Raoul Dufy

46
Fête at Le Havre, 1906
oil on canvas, 25½ x 31 in.
signed lower left: *Raoul Dufy*

One of the great themes of nineteenth-century painting in France was the holiday, showing either the private break from the daily routine or a festival of national importance. In the impressionist world this subject ranged from landscapes of boating parties on the Seine to city scenes showing Parisian streets bedecked with tricolored flags for Bastille Day. This theme was also important to Dufy. Indeed, working in and around the seaside city of Le Havre, Dufy often portrayed figures promenading on the boardwalks as well as walking along the beach. In contrast to the dramatic aspects of other fauve artists' work, Dufy's paintings capture the gay mood of the crowd, signaled by his trademarks of flags and sailboats.

This picture differs from the majority of his seacoast works in showing a large public holiday. Dufy has accordingly adjusted the scale of the scene, using a wider view so as to indicate the curve of the beachfront extending off to the horizon at the right. This long promenade is painted in a brilliant orange, with its tiny figures dressed in black. Warm tones are also used in the buildings at the upper left, in contrast to the bluish grays of the clouds rolling over the ocean.

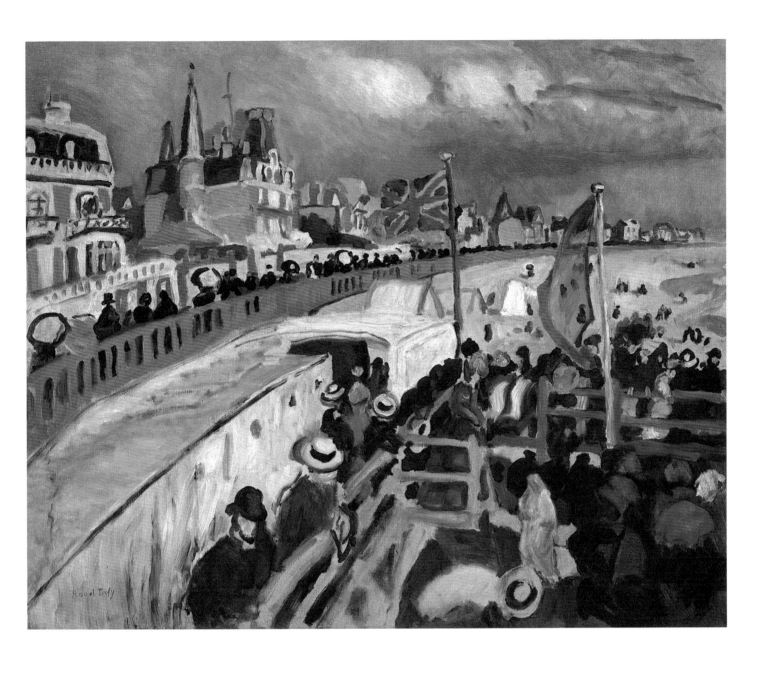

Albert Marquet
1874-1947

47
The Beach at Trouville, 1906
oil on canvas 25 x 31½ in.
signed in lower right: *Marquet*

During the years when Marquet's art was developing, he worked closely with Matisse. However, his most important paintings date from a summer spent with Dufy, working in and around the coastal city of Le Havre. Both artists were attracted not only to the brilliant sunshine of this setting but also to the intense colors and bold patterns found along the boardwalks and breakfronts.

Marquet's *The Beach at Trouville* is an extraordinary juxtaposition of these elements. The focus is on the tall wall stretched across the center of the composition, completely covered with yellow, blue, and red *affiches.* As if to add further pattern, this wall is counterpointed by the gaily striped red and white tents at the lower left. Yet, while this new attention to pictorial complexities is the dominant aspect of *The Beach at Trouville,* a lingering aspect of impressionism is also present, especially in the way in which the blue sky and tan sand directly portray the exact atmosphere of the scene.

Henri Matisse
1869-1954

48
Study for "Luxe, Calme et Volupté," Saint-Tropez, 1904
oil on canvas, 15 x 21½ in.
signed in lower right corner: *Henri Matisse*

Matisse spent the summer of 1904 with Henri Edmond Cross in Le Lavandou and with Paul Signac in nearby Saint-Tropez on the Mediterranean. There the artist painted this small canvas, inspired by the famous couplet thrice repeated in Baudelaire's *L'Invitation au voyage:* "Là, tout n'est qu'ordre et beauté, Luxe, calme et volupté."

The color of this study, as Alfred Barr has pointed out, "is bolder or at least more brilliant than any Matisse had hitherto used. The sky is pink and yellow, the tree trunk indigo and scarlet, the ground vermilion, orange and crimson. The figures are equally arbitrary in hue: the standing woman for instance is drawn in heavy blue and lavender lines and modeled with complementaries of rose and pale green. The modeling of the reclining figure is done with turquoise in the light, mauve in the shading, bounded by heavy blue outlines. She casts a deep green shadow and has scarlet hair. Such color would not have seemed radical to Signac and Cross but it is certainly very far removed from Matisse's own sober, tonal palette of the previous three years. What is significant about the color, however, is not so much its brightness or its radical departure from 'nature' as the freedom with which Matisse uses it. Though still tentative and on a small scale, this study, taken in detail, is thoroughly fauve and at the same time possesses that extraordinary beauty of color which distinguished Matisse's painting from that of both his neo-impressionist seniors and his fauve colleagues who were to assemble in full strength within the coming year." (A. H. Barr, Jr., *Matisse—His Art and His Public* [New York, 1951], 59-60.)

Henri Matisse

49
Still Life with Napkin and a Purro II, 1904
oil on canvas, 10½ x 13¾ in.
signed lower left: *Henri Matisse*

Matisse spent the summer of 1904 in Saint-Tropez on the Mediterranean, working with Signac, who then lived in this coastal city, and with Cross, who was nearby at Le Lavandou. Matisse's first works completed in Saint-Tropez, however, derive more from his studying the paintings of Cézanne. The first version of this picture, *Still Life with Napkin and a Purro I* belongs in this category. The influence of Cézanne was not long lasting, and before the end of the summer, Matisse had adapted the neo-impressionist features of Signac's and Cross' style into his work.

Interestingly, *Still Life with Napkin and a Purro II* is a fairly exact transcription of the large initial picture, both in terms of composition and subject matter. The aspects typical of a Cézanne still life arrangement—vessels, fruit, and folded napkin seen at an angle on the table top—are continued. However, in making the second version Matisse fully adapted Signac's pointillist technique, using small dots of intense color and the direct juxtaposition of complementing hues.

Henri Matisse

50
Open Window, Collioure, 1905
oil on canvas, 21¾ x 18⅛ in.
signed in lower right corner: *Henri-Matisse*

Painted during the summer of 1905, while Matisse and Derain worked together at Collioure, this canvas was exhibited at the historic Salon d'Automne of 1905, where fauvism manifested itself for the first time and received its name. It was one of the works which particularly aroused the ire of public and critics, and as such was reproduced on the now famous page of *L'Illustration* devoted to the exhibition.

In the words of Alfred Barr: "The *Open Window* is painted as thinly and freely as a watercolor, the white sizing of the canvas shining through the thin glazes of paint or between the strokes. Through the window, framed in brilliant green ivy, one sees the Collioure fishing boats with vermilion masts floating on pink and pale blue water. The scarlet flowerpots on the balcony serve as a reflexive complementary to the ivy. The view is reflected in the open glass shutters. The wall which surrounds the window is bright green-blue at the left, dark green above and, at the right, brilliant red-violet, a sequence of colors completely artificial but brilliantly effective as a frame to the brighter and more agitated central part of the picture. The *Open Window*, like so many fauve paintings, is not consistent in style throughout. Passages of impressionist and neo-impressionist broken color alternate with areas of broad, flat, even tone. Similarly certain areas follow somewhat intensified local color—that is, the natural color of objects—while other surfaces are quite arbitrary in tone. Fifteen years before this, Gauguin and his Synthetist and Nabi followers had used flat tones of strong color. Van Gogh and, later, Vlaminck had used more brilliant color with greater dramatic intensity, but in Matisse's *Open Window* there is a lyrical freshness and purity of color, a kind of gay informal spontaneity which is new. Even the sketchiness and inconsistencies seem virtues at this stage of Matisse's development." (A. H. Barr, Jr., *Matisse—His Art and His Public* [New York, 1951], 72.)

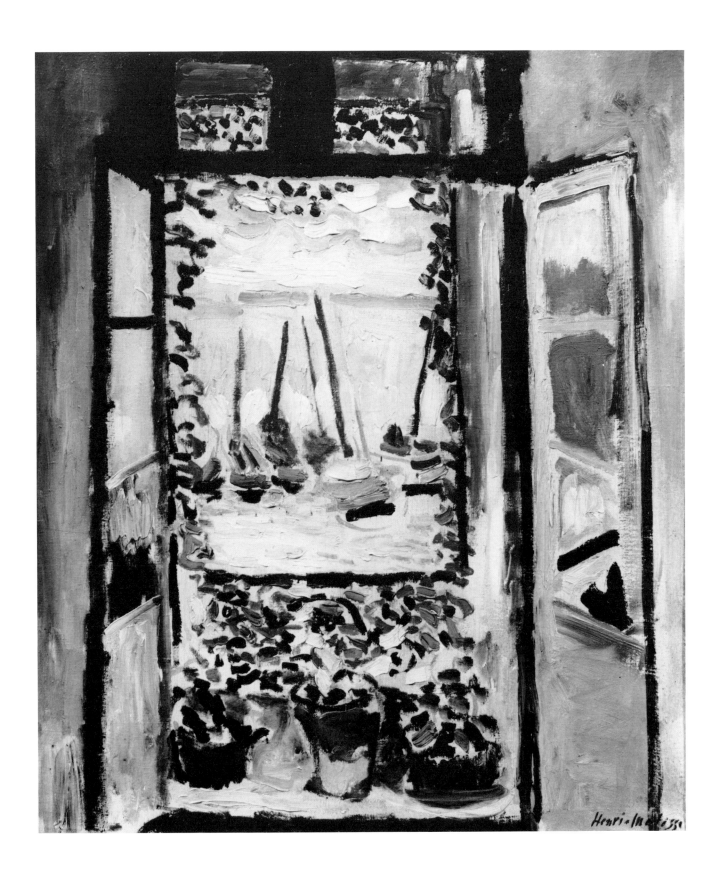

Maurice de Vlaminck
1876-1958

51
Tugboat on the Seine, Chatou, 1906
oil on canvas, 19¾ x 25⅝ in.
signed in lower left corner: *Vlaminck*

Of all the fauves, the "wild beasts," Vlaminck was unquestionably the wildest. Proud of his lack of discipline, of his muscular strength, of his uncouthness, he reveled in an attitude of revolt and of contempt for everything that involved learning or reason. He avoided nearby Paris and the company of other painters, instead painting ardently with his comrade Derain in Chatou, which became to fauvism what Argenteuil had been to impressionism.

In 1901, Vlaminck had received a profound shock from the first large van Gogh exhibition ever held in Paris. This exhibition, assembled roughly ten years after the painter's suicide, left a deep impact not only on Vlaminck but on all the young artists of his generation.

Back in Chatou, Vlaminck began to assimilate van Gogh's lesson. "I heightened all the tones," he wrote later, "I transposed into an orchestration of pure colors all the feelings of which I was conscious. I was a barbarian, tender and full of violence. I translated by instinct, without any method, not merely an artistic truth but above all a human one. I crushed and botched the ultramarines and vermilions, though they were very expensive and I had to buy them on credit." Indeed, Vlaminck's work began to anticipate ever more strongly the fauve explosion of 1905.

When Matisse went to visit Derain and Vlaminck in Chatou, he was "moved to see that these very young men had certain convictions similar to my own." It was Matisse who invited the two artists to participate in the historic fauve display at the Salon d'Automne of 1905. One of Vuillard's Nabi friends, Maurice Denis, stated upon visiting that exhibition: "As in the most extreme departures of van Gogh, something still remains of the original feeling of nature. But here one finds . . . painting outside every contingency, painting in itself, the act of pure painting. All the qualities of the picture other than the contrasts of line and color, everything which the rational mind of the painter has not controlled, everything which comes from our instinct and from nature, finally all the factors of representation and of feeling are excluded from the work of art. Here is, in fact, a search for the absolute. Yet, strange contradiction, this absolute is limited by the one thing in the world that is most relative: individual emotion. . . ."

Vlaminck, for his part, would not accept Denis' contention that he had excluded from his canvases "everything which the rational mind has not controlled." To him, as he has said, fauvism "was not an invention, an attitude, but a manner of being, of acting, of thinking, of breathing." More robust, more ready to follow instinct unimpeded by doubts or intellectual preoccupations, he attained a violence of assertion which went beyond that of all his friends. "To create presupposes pride," he later explained, "an immeasurable pride perhaps! You have to have confidence in yourself, to feel the exclusive need of expressing what you feel independently of any exterior support. It is possible also that this frank ignorance, this unconscious simplicity, preserves us from experiments in which we might lose ourselves."

In spite of the powerful creative urge which presided over Vlaminck's feverish output of those years—or possibly because of it—he did not always attain a complete balance of purpose and expression; but where this is achieved, as in the present canvas, the vigorous qualities of his paintings are like the triumphant sound of trumpets.

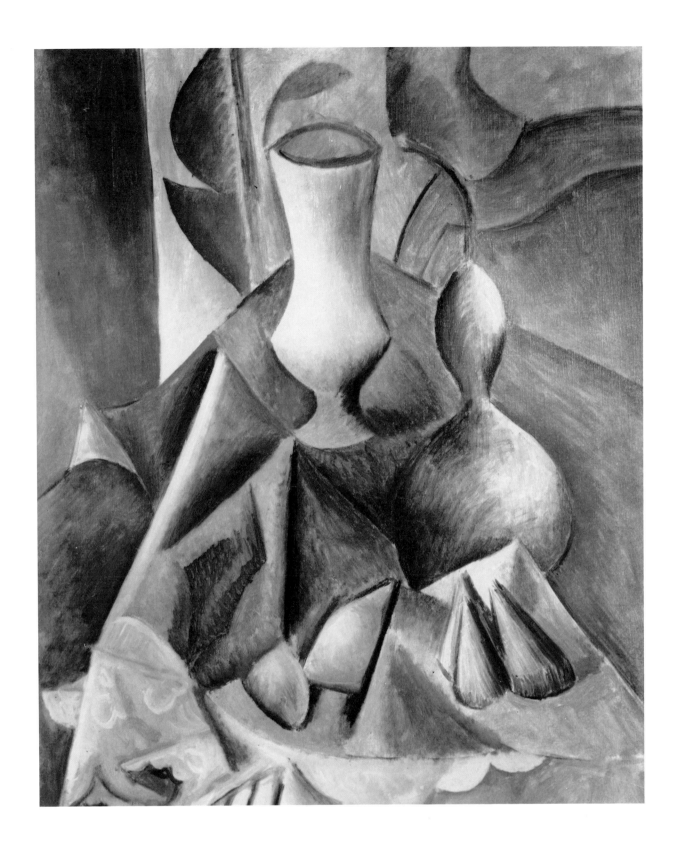

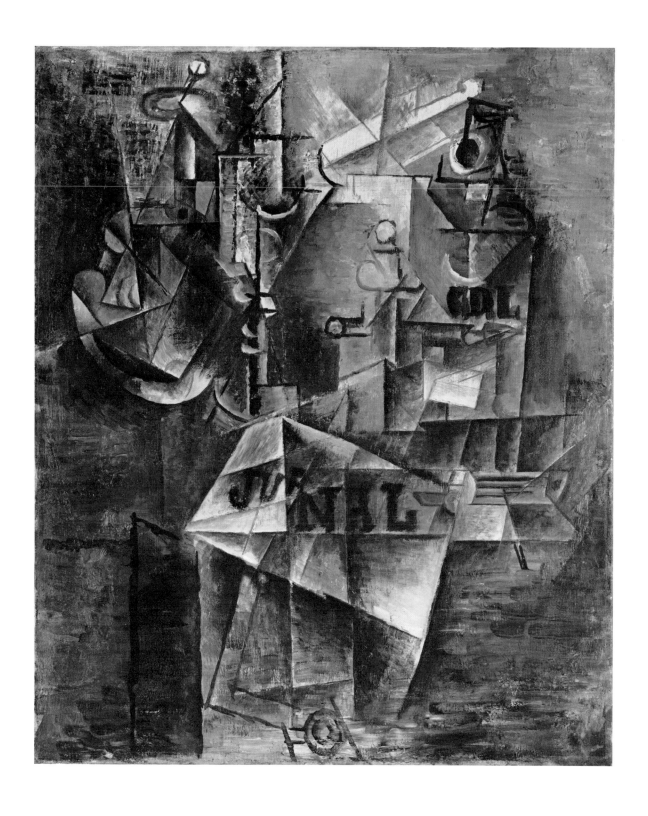

Pablo Picasso

58
Still Life (Le Journal), 1912
oil on canvas, 18 x 15¼ in.

Despite the seeming abstraction of Picasso's and Braque's pictures during the high period of analytical cubism, each artist continued to maintain elements of realism. In this small still life numerous objects are recognizable within the complex scaffolding formed from the linear structure and its painterly articulation. At the lower center is the folded newspaper, recognizable not only from its lighter tonality but more clearly by the letters J[O]URNAL. Beneath this paper is the front of the table top upon which the still life rests, with loosely stated lines marking the drawer knob and a piece of decorative molding. Three others letters are included, placed above at the right, of which the last two are legible as AL. Directly above the letters is a bottle, and below a pen with a triangular nib, set in a horizontal alignment. To the left of the pen and directly above the JU, is a glass with an elongated stem.

Pablo Picasso

59
Still Life with a Bottle of Maraschino, 1914
oil on canvas, 15 x 18¼ in.
signed and dated lower right: *Picasso 1914*

In 1911 Picasso and Braque were joined in their cubist adventure by another Spanish painter, Juan Gris. His geometric compositions were painted with a palette of bright colors, in direct contrast to the nearly monochromatic and more randomly composed schemes of Picasso and Braque. Inspired perhaps by Gris, Picasso turned to a brilliant coloration in painting in the summer of 1914, using hues of an intensity even greater than Gris'. Painted in Avignon, these 1914 works are also more decorative, both in Picasso's scattering of multicolored pointillist dots throughout the composition and in his selection of patterned or textured objects to make up the still life groupings.

The Whitney *Still Life with a Bottle of Maraschino* is a fine example of these Avignon pictures. Centered on a tall bottle of "La Negrita" rum with its distinctive diamond pattern, the composition also includes two glasses, one at the far left and the other at center right, placed above a cut piece of fruit. Picasso's familiar ace of clubs card and *journal* are to the left of the bottle, balanced by a dish of *Gaufrettes* on the right. This visual activity continues behind the assemblage, with the vertical molding at the left and the more linear dado on the right.

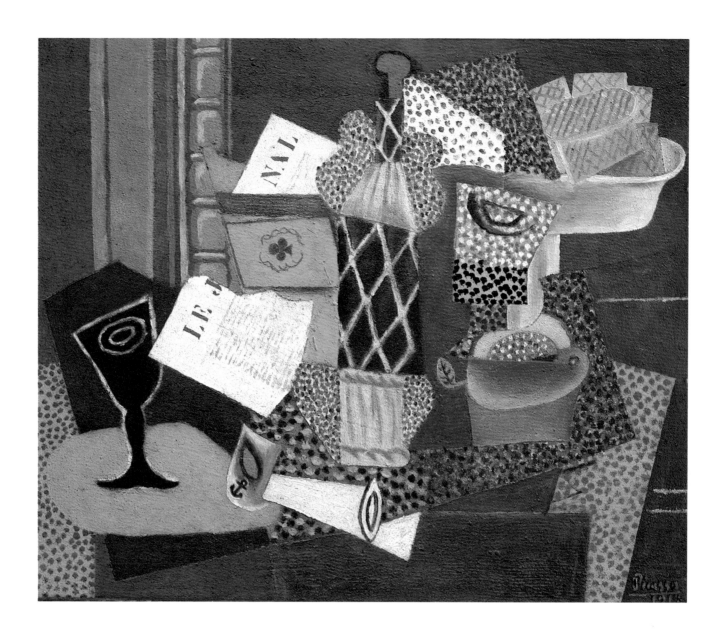

141

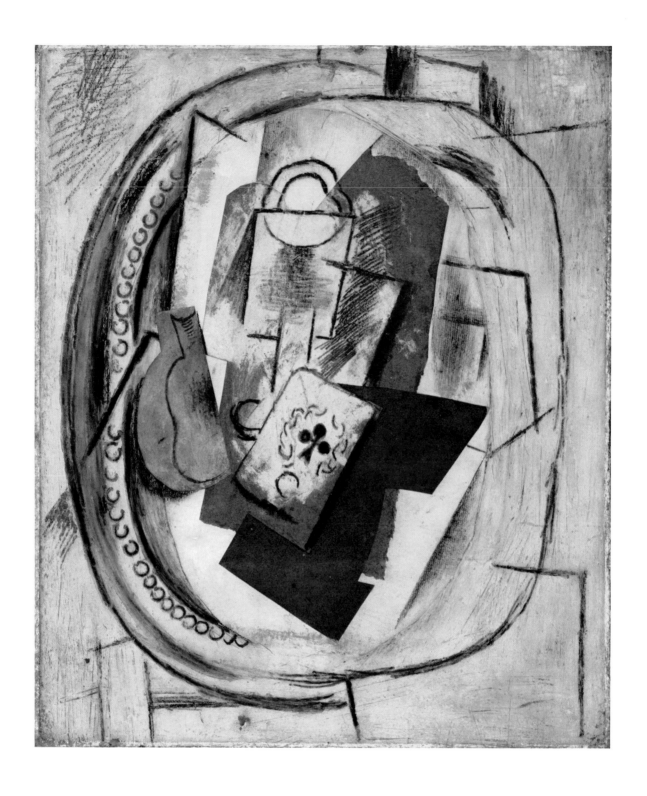

Pablo Picasso

60
Ace of Clubs, 1914
oil, paper collage, pencil, and ink on
canvas mounted on wood, 18 x 15¼ in.
Yale University Art Gallery, John Hay
Whitney, B.A. 1926, Honorary M.A. 1956,
Collection

Whereas it was Braque who invented *papier collé*
at the end of the summer of 1912, Picasso made
more extensive use of the technique over the next
two years. Although some heads and figures ap-
pear in collages, the still life was the principle
theme of the *papier collé*, as it also was for these
artists' contemporary paintings and drawings.

Part of the interest in collage was the greater
pictorial clarity of its structure, a quality which
answered the dilemma of the increasing abstrac-
tion in the high analytical style. Legibility of the
subjects is certainly an aspect of this collage,
which combines several motives seen in other
works of this period. At the left an oval piece of
yellow paper provides the shape of the pear, while
the cut-open interior of the fruit is drawn onto the
pasted element. Next to the pear is the ace of clubs
card, and above it the more abstracted glass.
Other paper elements suggest cloth on the table
top, while the table's oval form and its decorative
molding at the left are drawn directly onto the
painted support.

Pablo Picasso

61
Seated Man, 1918
gouache, 10½ x 8¼ in.
signed and dated in upper right corner:
Picasso 1918

In 1917 Picasso went with Cocteau to Rome to de-sign scenery and costumes for a ballet. The con-tact with a new *milieu* and with Italy revived his interest in classical forms and resulted in a num-ber of representational paintings. Yet he did not abandon cubism. In a series of drawings, some of which took their departure from likenesses of his wife (a Russian dancer he had met in Rome and married the following year), he showed himself preoccupied with figures seated in an armchair. In all of these—as in this gouache—the arabesque of the arm of the chair is combined with flat pat-terns derived from the sitter, but there are only a few cases in which the background reveals the *trompe l'oeil* elements to be found here.

Cubism, as defined by Picasso's lifelong friend D.-H. Kahnweiler as early as 1920, "has given painting an unprecedented freedom. It is no longer bound to the more or less realistic optical image which describes the object from a single viewpoint. It can, in order to give a thorough rep-resentation of the object's primary characteristics, depict them by means of stereometric drawing on the plane, or, through several representations of the same object, can provide an analytical study of the object which the spectator then fuses into one again in his mind. The representation does not necessarily have to be in the closed manner of the stereometric drawing; colored planes, through their direction and relative position, can bring together the formal scheme without uniting in closed forms. . . . Instead of an analytical de-scription, the painter can, if he prefers, also create in this way a synthesis of the object, or in the words of Kant, 'put together the various concep-tions and comprehend their variety in one per-ception.' "

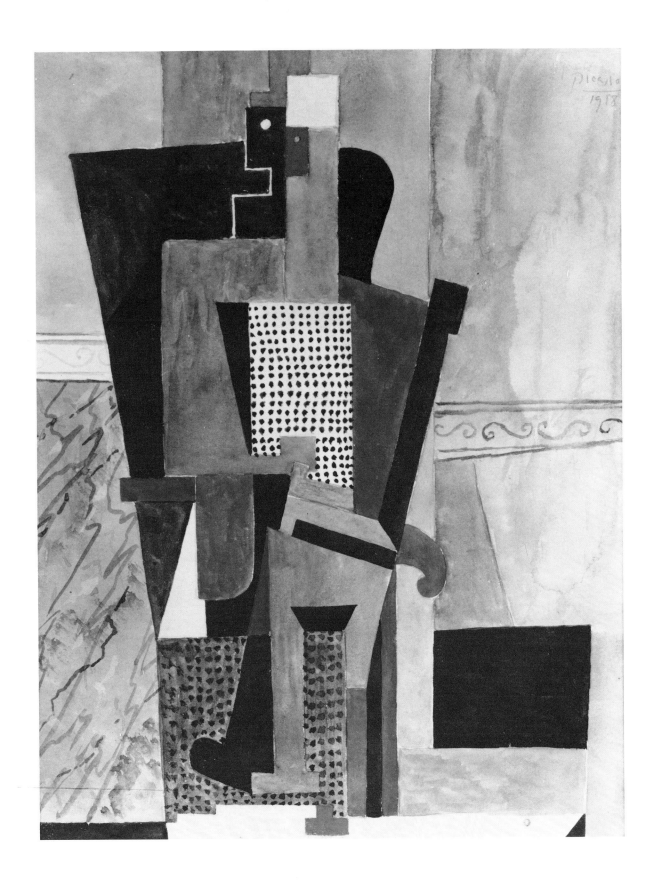

145

Other Twentieth-century Works

Other Twentieth-century Works

Balthus (Balthasar Klossowski)
b. 1908

62
Le Salon, 1942
oil on canvas, 45¼ x 57⅞ in.
signed and dated in lower left corner:
Balthus 1942
Museum of Modern Art, New York, Estate
of John Hay Whitney, 1983

Nobody has described better than Albert Camus the haunting and serene world of Balthus, with its moods of innocence and perversity, with its awkward and yet graceful figures:

"Balthus has a style—something more and more rare. And his manner is peculiar to itself. It seems to me that one could define it satisfactorily by saying that his painting emerges from its native bounds in proportion as it is more realist. For Balthus knows that there is no such thing as solitary creation and that to correct reality it is necessary to utilize reality instead of turning one's back on her as is done by so many of our contemporaries. He knows that it is easier to shock than scandalize. Nature is not ugly, she is an object of beauty. If she is unsatisfactory, that is owing to the fact that she is incessantly in movement, both in her creatures and settings. One must therefore compass nature, not deny her. One must select, not destroy. Balthus selects his model at its most accessible point and simultaneously fixes the emotion and the scene with such precision that we are left with the impression of contemplating, as through glass, figures that a kind of enchantment has petrified, not forever, but for the fifth fraction of a second,

after which movement will resume—the difference being that that fifth of a second still endures at this moment of writing. And we then perceive that nature, when viewed in such a moment of silence and immobility, is stranger than the strange monsters that take birth in the imagination of men. It is indeed reality, the most familiar kind of reality, with which we are confronted. But we learn, thanks to Balthus the interpreter and translator, that until now we had not really seen it, that lurking amidst our apartments, familiars and streets were disquieting faces against which we had closed our eyes. We especially learn that the most everyday reality may have the distant and unwonted air, the sonorous sweetness, the muffled mystery of lost paradises."

The present picture was painted in Fribourg, Switzerland, where the artist, after being demobilized from the French Army, spent the remainder of the war with his wife and children. The figure of the reading girl in the foreground had appeared already, with slight variations, in his canvas, *The Children*, painted in 1937 and owned by Pablo Picasso.

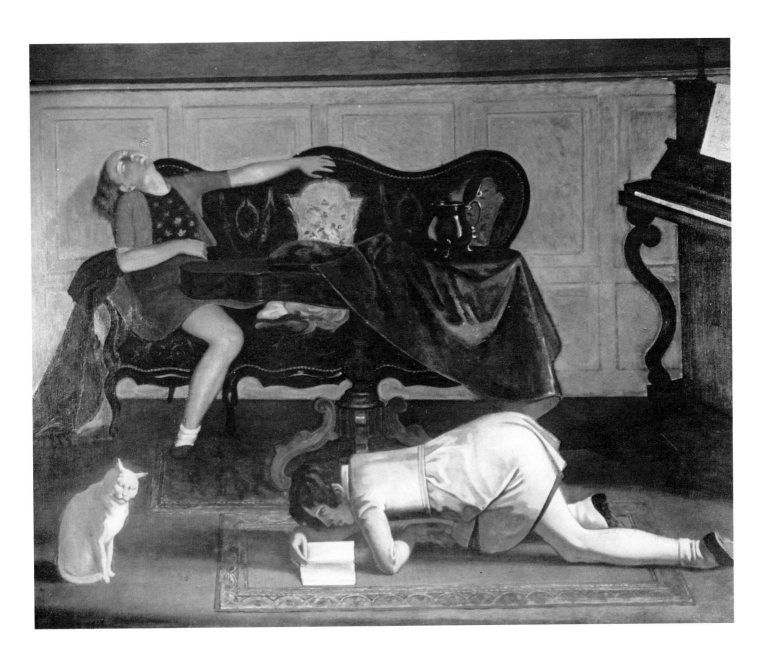

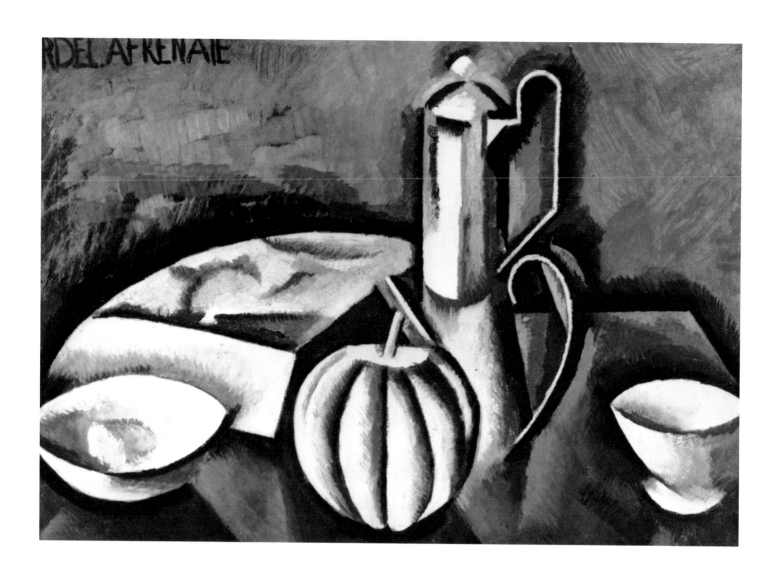

Roger de la Fresnaye
1885-1925

63
Still Life, Coffee Pot, and Melon, c. 1911
oil on canvas, 21½ x 31 in.
signed in upper right: R. DE LA FRENAIE [sic]

Braque's and Picasso's development of cubism can be best characterized as being a private concern, as they worked only in close contact with each other and did not exhibit in the major Parisian shows. Nevertheless, by 1911 several other artists had begun to work in a cubist manner, adapting aspects of Picasso's and Braque's paintings. Among the most gifted of these later cubists was de la Fresnaye. After a period of earlier work in a post-impressionist style derived from Gauguin's Pont-Aven pictures, de la Fresnaye began to paint in a cubist style in 1910, only a year before this small still life was completed.

Just as they had for Braque and Picasso, Cézanne's paintings provided the starting point for many of these later cubists. This still life shows the impact of Cézanne on de la Fresnaye, both thematically in his choice of simple, humble objects, and formally, in the higher viewpoint assumed and in the emphasis on contours and painterly transitions. De la Fresnaye's works of this period are also more legible than the contemporary paintings by Braque and Picasso. Here a bowl and coffee pot are joined by a whole melon and a sliced piece, while a large section of cheese is placed in the background. Within this varied grouping de la Fresnaye follows Cézanne in emphasizing correspondences of forms and the fitting together of overlapping shapes. The coffee pot, with its looping thin handle, appears in two other works of this period.

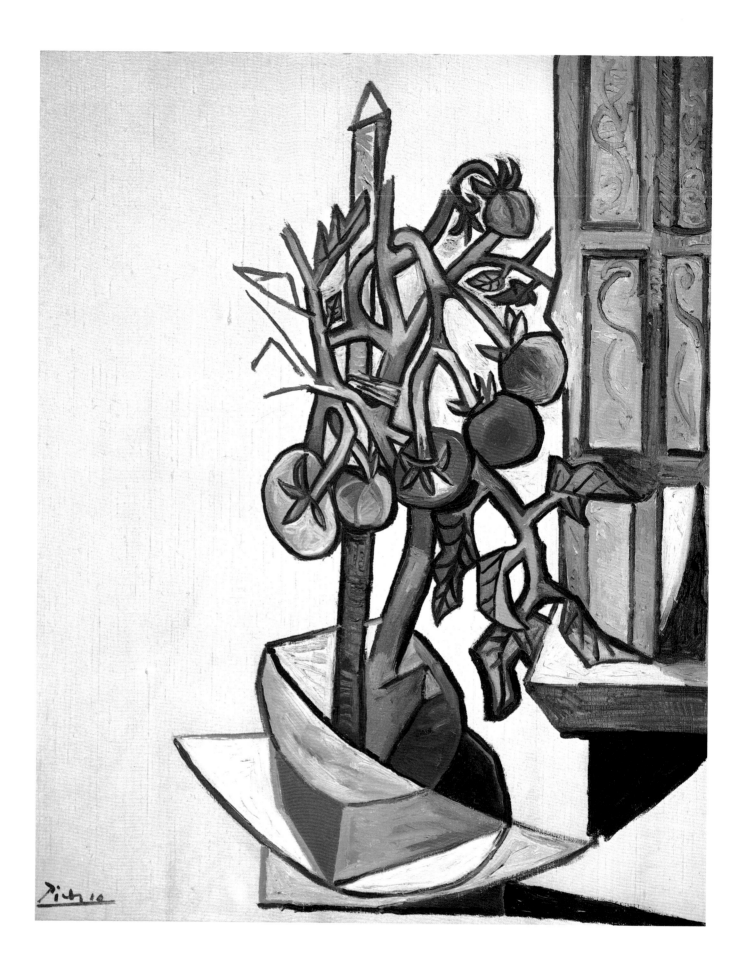

152

Pablo Picasso

64

Tomato Plant in Front of a Window, Paris,
August 7, 1944
oil on canvas, 36¼ x 29 in.
signed in lower left corner: *Picasso* (dated
7/8/44 on the stretcher)

If history were written in terms of art, the Second World War could be defined as an event circumscribed by two works of Picasso: *Guernica* of 1937 and *Le Charnier* of 1945. Yet in spite of the horror of violence so graphically recorded in these large paintings, the artist's output during the war years was prodigious. Among his canvases are numerous still lifes, including a whole series representing a tomato plant near a window. Many of these still lifes, as Roland Penrose has said, "are permeated with a sense of death whose emblem appears frequently in company with a shrouded lamp and withered plants." All of them show, in the words of Alfred H. Barr, Jr., "some vestiges of cubism in the angular cutting of shapes and shadows, the free handling of perspective and the extension of profiles into space. However . . . the characteristic shapes of objects are not disintegrated as in cubism, but are fortified by the use of heavy dark contours."

A few days before the Germans were driven from Paris, Picasso made at least five still lifes of a tomato plant. They were among the works which the artist showed to John Pudney, an RAF squadron leader and poet who was among Picasso's first English visitors after the Liberation. Pudney reports looking with his host at canvases of "the pot of growing tomatoes which stood in the window" and quotes him as saying: "A more disciplined art, less unconstrained freedom in a time like this is the artist's defence and guard. . . . Most certainly it is not a time for the creative man to fail, to shrink, to stop working. . . ."

Rufino Tamayo
b. 1899

65

Women

oil on canvas, 35⅝ x 27⅝ in.
Museum of Modern Art, New York, Estate
of John Hay Whitney, 1983

Tamayo was born in 1899 in Oaxaca, a province
in the southwest of Mexico. This area was a center
of pre-Columbian civilization, and Tamayo is a
descendant of this culture, his parents being Za-
potec Indians. They died when Tamayo was
eight, and he was sent to Mexico City to live with
his aunt. It was here that his first interests in art
were awakened, and by 1921, at the age of twenty-
one, Tamayo not only had attended the School of
Fine Arts but had also been appointed head of the
drawings department in the National Museum of
Archeology, where the principal holdings were
pre-Columbian art.

This combination of family background and
professional interest led to the Mexican themes in
Tamayo's early work. This remained the case
even after he moved to New York in 1938, as we
can see in this.canvas painted a year after he left
Mexico. *Women* is one of a pair of pictures show-
ing the theme of Mexican women at work in do-
mestic settings. More contemporary Mexican
qualities may also be found in its formal charac-
teristics, for Tamayo used thin applications of
paint washing into the canvas, creating a surface
akin to that of the frescoed surfaces of the Mexi-
can muralists of his generation. Tamayo's more
abstract positioning of the figures, however, gives
his work an international, modern quality, a
characteristic which he continues in his later
paintings.

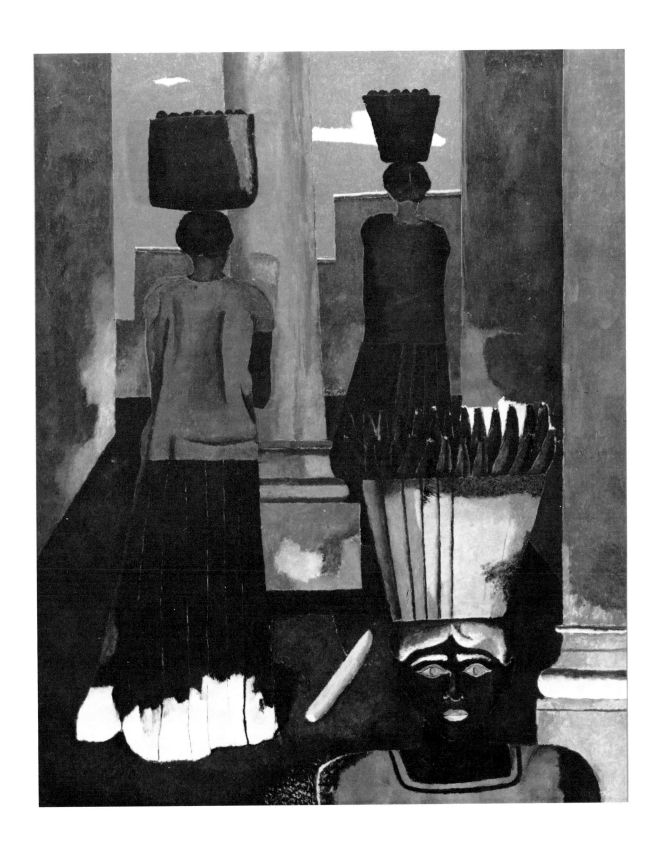

American

George Bellows
1882-1925

66

Club Night, 1907
oil on canvas, 43 x 53 in.
National Gallery of Art, The John Hay
Whitney Collection, 1982

Although George Bellows painted portraits, landscapes, and genre scenes, he is best known for his boxing pictures. Bellows painted a total of six oils on the subject of prizefighting; among them: *Club Night*, 1907, (National Gallery of Art), *Both Members of This Club* (1909, National Gallery of Art), and *Introducing John L. Sullivan* (1923, Whitney Museum of American Art).

Painted in August and September of 1907, *Club Night* is Bellows' first boxing oil and, with *Stag at Sharkey's* (1909, Cleveland Museum of Art) and *Both Members of This Club*, forms a trio of early works that are dynamic and action filled. These paintings display the artist's rapid, slashing brushstrokes, dramatic lighting, and the close viewpoints and cropping that give them a heightened sense of realism. All three of these early canvases are based on Bellows' memory of fights he attended at Tom Sharkey's Athletic Club, located near his studio. Since boxing was illegal in New York at the time, the backrooms of bars became

"athletic clubs" and pugilists became club "members." These paintings conjure up the masculine world at Sharkey's, with its cigar smoke, hot center light, and restless spectators that are reminiscent of the work of Daumier or Goya in their caricatured faces. But *Club Night*, showing two unidentified boxers in action, is not as intensely violent as the other two early oils. Rather, it depicts a graceful dance made up of the rhythmic movements of the fighters' arms and legs.

Club Night springs from the tradition of American sporting paintings by artists such as George Caleb Bingham, Winslow Homer, and Thomas Eakins, and it is this tradition that held special appeal for John Hay Whitney, one of the greatest sportsmen of his era. Mr. Whitney's collection contained numerous scenes of boxing, rowing, and equestrian activities, and it is interesting to note that *Club Night*, purchased in 1930, was one of his earliest acquisitons.

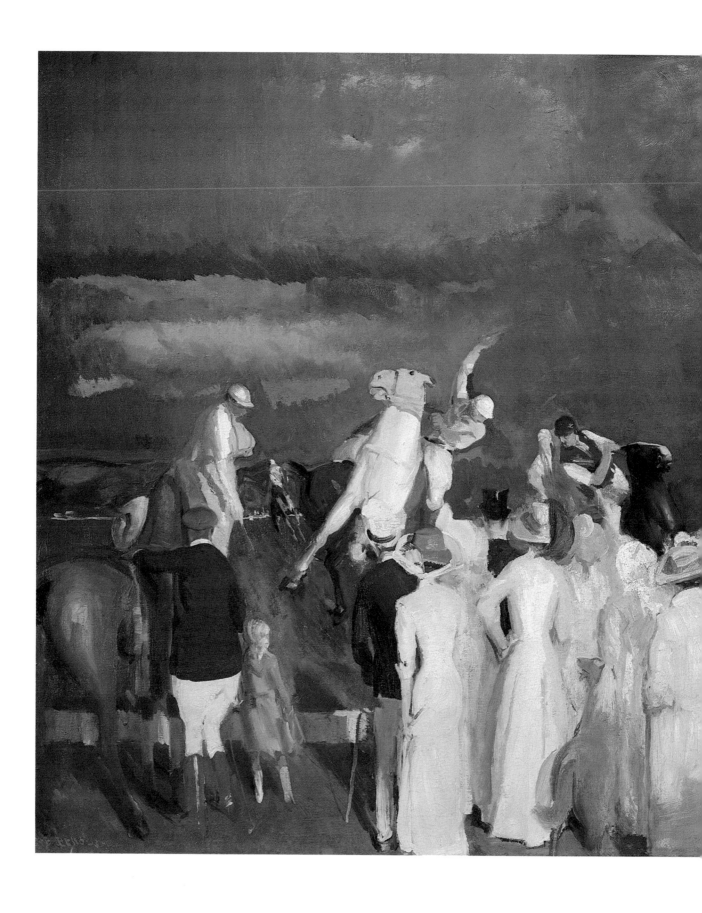

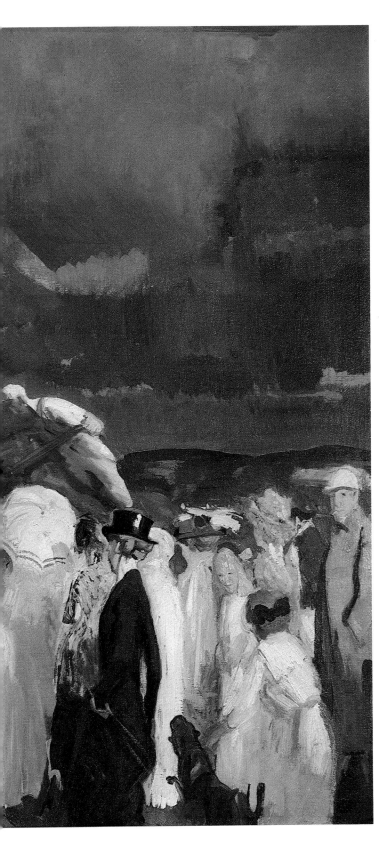

George Bellows

67
Crowd at Polo, 1910
oil on canvas, 44½ x 63 in.

Fascinated with lively, sporting action and the crowd's response to it, Bellows depicted not only boxing and tennis, but polo as well. He was introduced to the sport in May 1910, when his friend and patron Joseph Thomas took him to the Gould estate in Lakewood, New Jersey. With characteristic directness and humor Bellows observed in a letter to his friend Professor Joseph Taylor: "I've been making studies of the wealthy game of polo as played by the ultra rich. And let me say that these ultra rich have nerve tucked under their vest pocket. It's an Alladin's lamp sort of game. You wish to be a hundred yards to your left, you kick your heels—and there you are. Sometimes there's a conflict of wishing and Alladin No. 1 or 2 goes over the genii's head onto his tender clavicles and he doesn't get up.

"The players are nice looking, moral looking. The horses are beautiful. I believe they brush their teeth and bathe them in goat's milk. It is a great subject to draw, fortunately respectable. . . ."

Bellows completed two paintings of the subject, identical in size. *Polo at Lakewood* (1910, Columbus Museum of Art) shows only a small section of spectators, concentrating on the jumble of clashing horses and men. *Crowd at Polo* was produced in November from sketches made the previous spring and is, as its title implies, primarily a depiction of the audience for the match. Genteel women in light-colored dresses, wearing hats or carrying parasols, and neatly attired gentlemen stand calmly observing the leaning and swinging players and jumping and galloping horses. The image is a remarkable contrast to Bellows' celebrated boxing paintings of 1907 and 1909 which include rough, almost vicious crowds, raucously adding to the excitement of the bout.

Crowd at Polo is broadly and vigorously painted, in the manner of the best of Bellows' early paintings. John Hay Whitney, an avid horseman, made this work one of his earliest purchases.

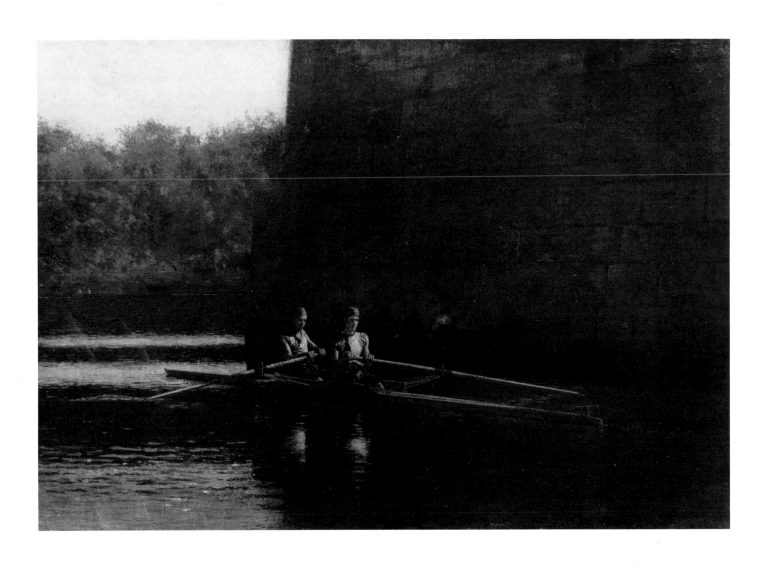

Thomas Eakins
1844-1916

68

The Oarsmen (The Schreiber Brothers), 1874
oil on canvas, 15 x 22 in.
signed and dated in right center: *Eakins
1874*
Yale University Art Gallery, John Hay
Whitney, B.A. 1926, Honorary M.A. 1956,
Collection

After studying with Gérôme and Bonnat in Paris (1866–1869) and making a trip to Spain (1869–1870), which left a deep impact on him, the young Eakins returned to his hometown, Philadelphia, and there resumed an outdoor life which supplied him with many of his earliest subjects. Rowing was then one of the most popular sports; it inspired the artist to paint no fewer than six oils of oarsmen in their shells, a like number of watercolors, and a series of preparatory drawings for these. Eakins himself rowed and was friendly with various champions of the sport.

"Every picture of this series," Goodrich has stated, "was part of his daily life, every figure a portrait of someone he knew, every scene a familiar one. It was the material closest to him, presented with unconscious simplicity and truth. No trace of imitative style could be found in these works; they were products of an essentially original vision. Keen first-hand observation appeared in the truth to character of these rough sportsmen, with their natural, unstudied gestures and attitudes, in the almost photographic sharpness of details, in the fidelity to the color and atmosphere of this country—the high, remote skies, the strong sunlight, the clear air, the brown bareness of grass and trees and fields for half the year. These were things he had never learned in Gérôme's studio. Among painters of the time only Winslow Homer approached the fresh authenticity of these records of American outdoor life." (L. Goodrich, *Thomas Eakins—His Life and Work* [New York, 1933], cat. no. 66.)

Thomas Eakins

69
Baby at Play, 1876
oil on canvas, 32¼ x 48⅜ in.
signed and dated in lower right on the brick
pavement: *Eakins/76*
National Gallery of Art, The John Hay
Whitney Collection, 1982

The painting represents the artist's niece, Ella Crowell, child of Eakins' sister Frances (Mrs. William J. Crowell), playing in the sunlight in the backyard of the Eakins' Mount Vernon Street house in Philadelphia. She is about two years old.

While he submitted in Paris to the academic teaching of Gérôme, Eakins, in his letters home, showed himself greatly preoccupied with the artist's attitude towards nature, the need for direct observation, and the necessity to treat subjects which were observed instead of derived from history. The gist of his argument was that the painter must be faithful to nature, but nature seen and understood in the broadest way, recreated rather than slavishly copied. "The big artist," he wrote, "does not sit down monkey like and copy a coal scuttle or an ugly woman like some Dutch painters have done nor a dung pile, but he keeps a sharp eye on Nature and steals her tools. He learns what she does with light, the big tool, and then color, then form, and appropriates them to his own use. . . ." (Quoted in Lloyd Goodrich, *Thomas Eakins,* 2 vols. [Cambridge and London, 1982], 1, 31.)

These ideas might have prompted Eakins to make a careful study of the works of Courbet, then the foremost independent figure in the Paris art scene and certainly the most discussed one.

Nevertheless Eakins made no mention in his letters either of Courbet or of Manet, though both organized their own one-man shows in separate pavilions, specially built for the occasion, during the Paris World's Fair of 1867. Eakins visited this Fair, but in his reports home most of the space was devoted to the machinery.

However, unless we are prepared to believe in the simultaneous and unrelated appearance of similar artistic styles in America and in France, it would seem that *Baby at Play* is a record of Eakins' acquaintance with Courbet's work. The powerfully modeled figure of the child, the contrast of light and shadow, even the loose brushwork in the background seem related, at least distantly, to the Master of Ornans. Although Eakins by no means imitated Courbet and actually achieved in this painting a work of great originality and impact, it would seem that he could scarcely have arrived at this style without using Courbet's achievements as a stepping stone. As it is, this picture shows the artist forsaking the more methodical approach of his somewhat dry realism in previous works to achieve a softer and at the same time more forceful expression. In this respect, *Baby at Play* is not only a significant work, it is also a highly successful and extremely beautiful one.

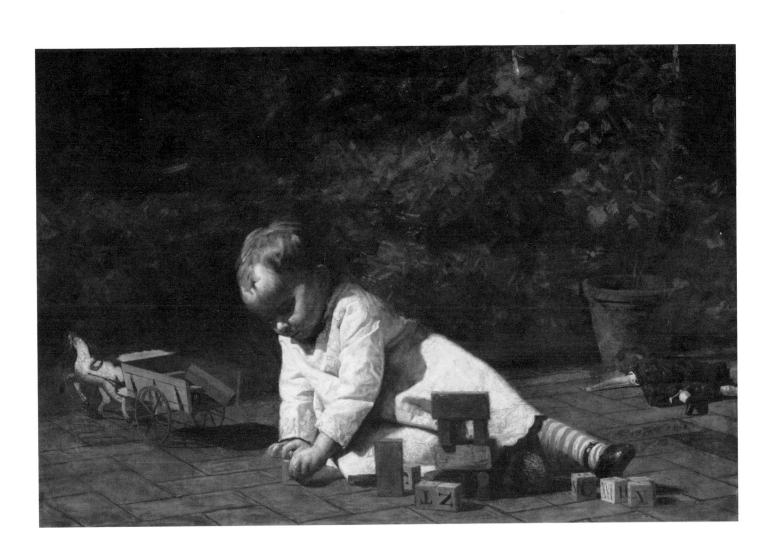

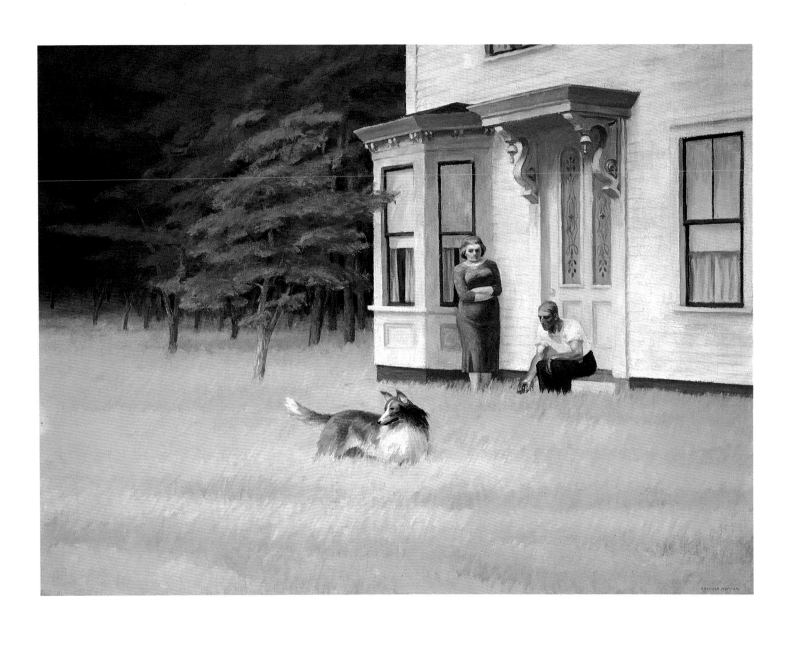

Edward Hopper
1882-1967

70
Cape Cod Evening, 1939
oil on canvas, 30¼ x 40¼ in.
signed in lower right corner: *Edward Hopper*
National Gallery of Art, The John Hay Whitney Collection, 1982

Born the same year as Bellows, once his fellow student, Hopper is—if not more realistic—more poetic in the moods that pervade his canvases. "My aim in painting," according to his own words, "has always been the most exact transcription possible of my most intimate impressions of nature." Yet this does not mean that he puts these down with the directness of a Monet or a Pissarro.

The artist, who generally spent his summers on the Cape, explained that *Cape Cod Evening* "is no exact transcription of a place, but pieced together from sketches and mental impressions of things in the vicinity. The grove of locust trees was done from sketches of trees nearby. The doorway of the house comes from Orleans, about twenty miles from here. The figures were done almost entirely without models, and the dry, blowing grass can be seen from my studio window in the late summer or autumn. In the woman I attempted to get the broad, strong-jawed face and blond hair of a Finnish type of which there are many on the Cape. The man is a dark-haired Yankee. The dog is listening to something, probably a whippoorwill or some evening sound."

John Singer Sargent
1856-1925

71
Venetian Courtyard, c. 1882
oil on canvas, 27½ x 31¾ in.
signed in lower right corner: *John S. Sargent*

John Singer Sargent was in Venice in 1880 and 1882 and painted there a series of informal genre scenes at which he excelled. These works form a distinct group within his career. For the most part, they utilize the same models, are similar in size, and are predominantly monochromatic studies of silver, black, and gray. Unlike other American artists who were drawn to Venice in the late nineteenth century, Sargent, in these paintings, does not portray the wide canals, festive crowds, or monuments of the city. Rather, these are more personal, intimate depictions of the working class, meeting and talking in side streets or alleys or working in austere interiors in the poorer section of Venice. While there is some interest in architectural elements (which is more apparent in Sargent's Venetian watercolors), the emphasis is on the detached figures who occupy deeply receding and sometimes mysterious spaces. In many ways, these genre paintings were important early works for Sargent in that they allowed him to work out compositional and tonal devices that he employed in 1882 on a grander scale in canvases such as *El Jaleo* and *The Daughters of Edward D. Boit*.

The Whitney painting, formerly known as *Spanish Courtyard*, belongs to the Venetian group and dates from about 1882. *Venetian Courtyard* depicts Sargent's favorite Venetian model, Gigia Viani, who stands holding a red fan. This same figure can be seen in a number of other paintings from this genre group, including *Italian Girl with a Fan* (1882, Cincinnati Museum of Art), *The Sulphur Match* (1882, Collection of Jo Ann and Julian Ganz, Jr.), and *Street in Venice* (1882, National Gallery of Art).

Gigia is usually shown dressed in a black shawl and a light dress (it is a cool pink in the Whitney painting) that is a manifestation of the dramatic light and dark contrasts that Sargent loved to bring to his canvases. The light with which these paintings are infused is more apparent in *Venetian Courtyard* than in the other interiors, because the arcade to the left allows the silvery Venetian light to penetrate the terracotta courtyard and its warm tan plaster walls. Although the palette is predominantly silver and gray, the painting is enhanced by brilliant touches of color, such as Gigia's pink dress and red fan and the pot of red flowers on the balustrade.

Venetian Courtyard is especially indebted to the work of two seventeenth-century artists: to the quiet interiors of Diego Velázquez and his bold use of black as an important color element and to the bravura brushwork seen in figures by Frans Hals. Sargent greatly admired the two old masters and had been to Spain in 1879 and to Holland in 1880 to study their work.

John Singer Sargent

Robert Louis Stevenson, 1885
oil on canvas, 20½ x 24½ in.
signed and dated upper left corner: *to R. L. Stevenson his friend John S. Sargent 1885*

This was painted during Sargent's second visit to the Stevenson's at Bournemouth in October 1885. The first portrait of Robert Louis Stevenson (1850–1894) was done in November 1884 at the request of Charles Fairchild of Boston, to whom Sargent had been recommended by Edwin Austin Abbey. This portrait showed the writer seated, but Sargent was dissatisfied with it and did not complete it until 1887.

The second version was dedicated and given to the sitter by the artist. Stevenson wrote about it to W. H. Low, October 22, 1885: "Sargent was down again and painted a portrait of me walking about in my own dining room, in my own velveteen jacket, and twisting as I go my own moustache: at one corner a glimpse of my wife, in an Indian dress, and seated in a chair that was once my grandfather's, but since seven months goes by the name of Henry James's, for it was there the novelist loved to sit—adds a touch of poesy and comicality. It is, I think, excellent, but is too eccentric to be exhibited. I am at one extreme corner: my wife in this wild dress, and looking like a ghost is at the extreme other end: between us an open door exhibits my palatial entrance hall and part of my respected staircase. All this is touched in lovely, with that witty touch of Sargent's: but of course it looks damn queer as a whole."

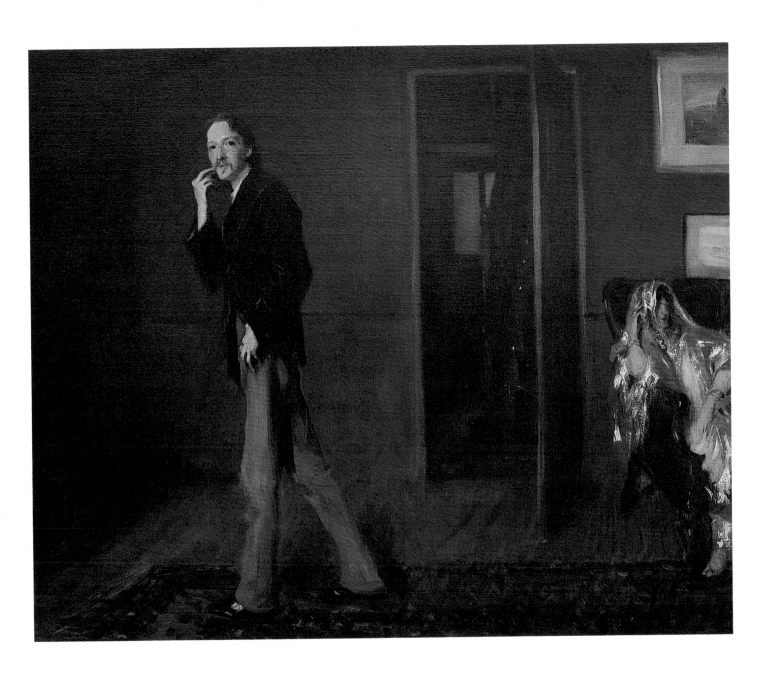

James McNeill Whistler
1834–1903

73
Wapping on Thames, 1860-1864
oil on canvas, 28½ x 40¼ in.
signed and dated in lower right corner:
Whistler. 1861.
National Gallery of Art, The John Hay
Whitney Collection, 1982

In 1859 Whistler settled in London after having studied in Paris where he had been particularly impressed with the work of Courbet. Fascinated by the Thames, Whistler stayed for many months at Wapping, sketching and painting on the river and its banks. The present picture, with Wapping warehouses in the background across the Lower Pool of London, was done from the balcony of "The Angel," an inn at Cherry Gardens. While working on this canvas, the artist explained in a long letter to his friend Fantin-Latour the various problems with which he was struggling (though many of the details to which he refers were eventually eliminated from the composition).

"I should like to have you with me," Whistler wrote, "in front of a picture on which I set all my hopes and which should become a masterpiece. . . . First of all, the scene is on a balcony, on a second floor, overlooking the Thames. There are three people: an old man in a white shirt—the one in the middle—who is looking through the window, then, at right, in the corner, a sailor . . . in a blue middy, the collar of a lighter blue turned up, who talks with a girl devilishly hard to paint. . . . I did her three times and don't want to exert myself; anyhow, if I mess around with her too much I won't have time to do the rest. At last, believe it or not, I managed to give her an EXPRESSION . . . a real expression. . . . Her hair is the most beautiful you ever saw! not a golden red but a *coppery* tone, more Venetian than anything you ever dreamt of! a yellowish white skin, or gilded, if you like. And with that famous expression I mentioned, she seems to be saying to her sailor: 'All this is very well, old bean, but I wasn't born yesterday.' You know, she winks and pokes fun at him. Now, all this is seen against the light and consequently in a chiaroscuro atrociously difficult to paint. But I don't think that I shall do her over again. Her throat is revealed; her chemise is almost completely visible and very well painted . . . and then a jacket . . . of white material with large ornaments and flowers of all colors. Don't say a word of this to Courbet! Through the window one sees nothing but the Thames which is like an etching and which was unbelievably difficult to render! The sky, for instance, is very true and boldly brushed. One corner appears behind the panes; it is quite dandy! More in the foreground there is a line of large vessels from one of which coal is being unloaded; closer to the window, the mast and yellow sail of a lighter. And directly behind the head of the girl . . . is the bowsprit of a large ship, the ropes and pulleys of which cross the entire picture." (Quoted in L. Bénédite, "Whistler," *Gazette des Beaux-Arts,* September 1, 1905.)

In spite of his intention not to alter the figure of the girl, the artist subsequently changed her completely, as well as the man next to her and, to a lesser extent, the sailor (traces of extensive pentimenti are still visible around the girl's head). After Fantin-Latour had come to London, Whistler informed him early in 1864 that he planned to send to the Paris Salon "the picture of the Thames which you saw. . . . The foreground is altogether changed and will, I believe, look very well in Paris. . . . There is a portrait of Legros and a head of Jo which are among my best things."

Indeed, the painting shows Joanna Hiffernan, an Irish beauty with copper-colored hair, who was the artist's model and mistress from 1860 to 1871. Next to Jo sits Alphonse Legros, French painter, sculptor, and engraver, who subsequently became a British subject.

Although the picture seems to have assumed its present aspect only some time late in 1863 or early in 1864, the artist retained the date 1861 which accompanies his signature.

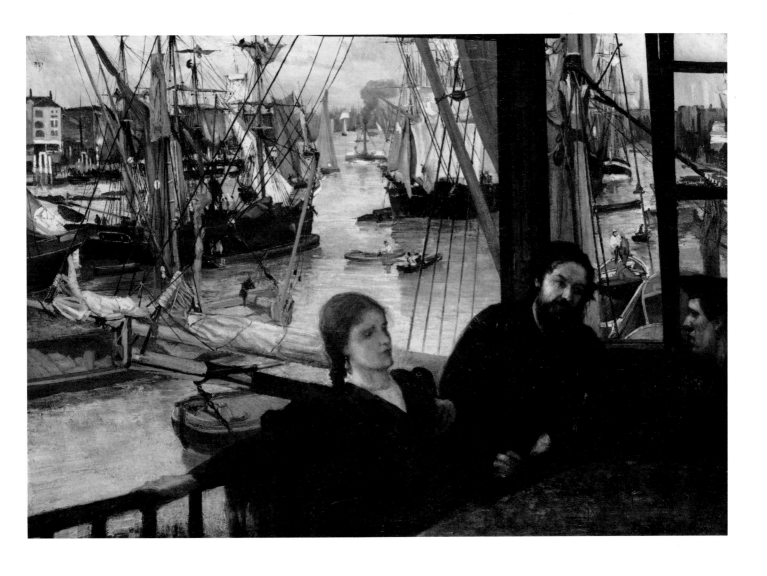

Further Reading

PRE-IMPRESSIONISM

J. Bouret. *The Barbizon School and 19th Century French Landscape Painting.* Greenwich, Connecticut, 1973.

K. Champa. *Studies in Early Impressionism.* New Haven, 1973.

R. L. Herbert. *Barbizon Revisited* (exh. cat.). Boston, 1962.

L. Nochlin. *Realism.* Baltimore, 1971.

The Art Institute of Chicago. *Frédéric Bazille and Early Impressionism.* Essays by J. P. Marandel and F. Daulte (exh. cat.). Chicago, 1978.

F. Daulte. *Frédéric Bazille et son temps.* Geneva, 1952.

R. Schmit. *Eugène Boudin.* 3 vols. Paris, 1973.

G. Boudaille. *Gustave Courbet.* Greenwich, Connecticut, 1970.

R. Fernier. *Gustave Courbet.* London, 1969.

R. Fernier. *La Vie et l'oeuvre de Gustave Courbet, catalogue raisonné.* Vol. 1, *Peintures 1819-1865,* Vol. 2, *Peintures 1866–1877, Dessins, Sculptures.* Lausanne and Paris, 1977–1978.

G. Mack. *Gustave Courbet.* New York, 1951.

H. Toussaint. *Gustave Courbet* (exh. cat.). Paris, 1977. Engl. trans. for Royal Academy, London, 1978.

G. Bazin. *Corot.* 2nd rev. ed., Paris, 1951.

A. Robaut. *L'Oeuvre de Corot: Catalogue raisonné et illustré.* 4 vols. Paris, 1905.

A. Schoeller and J. Dieterle. *Corot: Premier supplément à "L'Oeuvre de Corot" par A. Robaut et Moreau-Nélaton.* Paris, 1948.

A. Schoeller and J. Dieterle. *Corot: Deuxième supplément à "L'Oeuvre de Corot" par A. Robaut et Moreau-Nélaton.* Paris, 1956.

Wildenstein. *Corot.* Preface by J. Dieterle. New York, 1969.

K. E. Maison. *Honoré Daumier: Catalogue Raisonné of the Paintings, Watercolours and Drawings.* Vol. 1, *The Paintings.* London, 1968.

K. Berger. *Géricault and His Work.* Lawrence, 1955.

C. Clément. *Géricault.* Engl. trans. of 1879 ed., with supplement by L. Eitner. New York, 1974.

L. Eitner. *Géricault* (exh. cat.). Los Angeles, 1971.

P. Burty. "Théodore Rousseau." *Gazette des Beaux-Arts,* 24, no. 4 (1 avril 1868), 305-325.

Musée du Louvre. *Théodore Rousseau 1812–1867.* Catalogue by H. Toussaint, biography by M.-T. de Forges. Paris, 1968.

IMPRESSIONISM

The Metropolitan Museum of Art. *Impressionism: A Centenary Exhibition* (exh. cat.). New York, 1974–1975. (French ed., Paris, 1974).

J. Rewald. *The History of Impressionism.* 4th, rev. ed. Greenwich, Connecticut, 1973.

L. Venturi. *Archives de l'Impressionnisme.* 2 vols. Paris and New York, 1939.

J. S. Boggs. *Portraits by Degas.* Berkeley and Los Angeles, 1962.

P. Cabanne. *Edgar Degas.* Paris, 1957.

I. Dunlop. *Degas.* New York, Hagerstown, San Francisco, and London, 1979.

M. Guérin. *Dix-neuf portraits de Degas par lui-même.* Paris, 1931.

P.-A. Lemoisne. *Degas et son oeuvre.* 4 vols. Paris, 1946.

T. Reff. *Degas: The Artist's Mind.* New York, 1976.

D. C. Rich. *Degas.* New York, 1951.

F. Russoli. *L'Opera completa di Degas.* Milan, 1970.

L. Vauxcelles. in *Les Arts.* Special issue on the Gallimard collection. September 1908.

Wildenstein. *Degas' Racing World* (exh. cat.). Intro. by R. Pickvance. New York, 1968.

G. H. Hamilton. *Manet and His Critics.* New Haven, 1954.

A. C. Hanson. *Manet and the Modern Tradition.* New Haven and London, 1977.

T. Reff. *Manet and Modern Paris* (exh. cat.). National Gallery of Art, Washington, 1982.

D. Rouart and D. Wildenstein. *Manet: Catalogue raisonné.* Vol. 1, *Peintures,* Vol. 2, *Pastels, aquarelles et dessins.* Paris, 1975.

Grand Palais. *Hommage à Monet (1840–1926)* (exh. cat.). Paris, 1980.

J. Isaacson. *Claude Monet: Observation and Reflection.* Oxford, 1978.

W. C. Seitz. *Claude Monet.* The Library of Great Painters. New York, 1960.

D. Wildenstein. *Claude Monet: Biographie et catalogue raisonné.* 3 vols. Lausanne and Paris, 1974.

M.-L. Bataille and G. Wildenstein. *Berthe Morisot: Catalogue des peintures, pastels et aquarelles.* L'Art français. Paris, 1961.

Galeries Durand-Ruel. *Berthe Morisot (Madame Eugène Manet) 1841–1895.* Preface by S. Mallarmé. Paris, 1896.

J. Bailly-Herzberg. *Correspondance de Camille Pissarro.* Paris, 1980.

Museum of Fine Arts, Boston. *Camille Pissarro 1830–1903* (exh. cat.). Essays by R. Brettell *et al.* London and Boston, 1980–1981 (French ed., 1981).

L. R. Pissarro and L. Venturi. *Camille Pissarro—son art, son oeuvre.* 2 vols. Paris, 1939.

J. Rewald. *Camille Pissarro.* New York, 1963.

J. Rewald and L. Pissarro. *Camille Pissarro: Letters to His Son Lucien.* 4th rev. ed. London, 1980.

F. Daulte. *Auguste Renoir: Catalogue raisonné de l'oeuvre peint.* Vol. 1, *Figures 1860–1890.* Lausanne, 1971.

W. Gaunt. *Renoir.* 3rd rev. ed. Oxford, 1976.

G. Rivière. *Renoir et ses amis.* Paris, 1921.

A. Vollard. *Tableaux, pastels et dessins de Pierre-Auguste Renoir.* 2 vols. Paris, 1918.

POST-IMPRESSIONISM

J. Rewald. *Post-Impressionism from van Gogh to Gauguin.* 3rd rev. ed. New York, 1978.

G. Mauner. *The Nabis, Their History and Their Art.* New York and London, 1978.

K. Badt. *The Art of Cézanne.* Engl. trans. Berkeley, 1965.

B. Dorival. *Cézanne.* Engl. trans. New York, 1948.

J. Rewald, ed. *Paul Cézanne, Letters.* 4th rev. ed. New York, 1976.

J. Rewald. *Cézanne: sa vie, son oeuvre, son amitié pour Zola.* Paris. 1939.

The Museum of Modern Art. *Cézanne, The Late Work* (exh. cat.). W. Rubin, ed. New York, 1977.

M. Schapiro. *Paul Cézanne.* New York, 1952.

L. Venturi. *Cézanne: Son art, son oeuvre.* 2 vols. Paris, 1936.

J.-B. de la Faille. *The Works of Vincent van Gogh: His Paintings and Drawings.* rev. ed. Amsterdam, 1970.

V. van Gogh. *Verzamelde Brieven.* Amsterdam, 1953.

J. Lassaigne. *Vincent van Gogh.* Milan, 1971.

P. Lecaldano. *L'Opera pittorica di Van Gogh e i suoi nessi grafici.* I Classici dell'Arte, nos. 51-52. 2 vols. Milan, 1971.

R. Treble. *Van Gogh and His Art.* London, New York, Sydney, and Toronto, 1975.

B. Welsh-Ovcharov. *Vincent van Gogh and the Birth of Cloisonism* (exh. cat.). Toronto, 1981.

K. Berger. *Odilon Redon: Fantasy and Colour.* Trans. M. Bullock. New York, Toronto, and London, 1965.

C. Keay, ed. *Odilon Redon.* Intro. by T. Walters. London, 1977.

The Museum of Modern Art. *Odilon Redon / Gustave Moreau / Rodolphe Bresdin.* Redon essay by J. Rewald. New York, 1961.

R. Alley. *Portrait of a Primitive: The Art of Henri Rousseau.* Oxford, 1978.

J. Bouret. *Henri Rousseau.* Trans. M. Leake. Greenwich, Connecticut, 1961.

Y. le Pichon. *Le Monde du Douanier Rousseau.* Paris, 1981.

W. Udhe. *Henri Rousseau.* Paris, 1911.

D. Vallier. *Henri Rousseau.* Trans. from French ed. New York and London, 1963.

D. Vallier. *Tout l'oeuvre peint de Henri Rousseau.* Paris, 1970.

M. G. Dortu. *Toulouse-Lautrec et son oeuvre.* 6 vols. New York, 1971.

P. Huisman and M. G. Dortu. *Lautrec by Lautrec.* New York, 1964.

F. Jourdain and J. Adhémar. *Toulouse-Lautrec.* France, 1952.

M. Joyant. *Henri de Toulouse-Lautrec.* Paris, 1926-1927.

Paul Pétridès. *L'Oeuvre complet de Maurice Utrillo.* Paris, 1959.

S. Preston. *Edouard Vuillard:* New York, 1972.

A. C. Ritchie. *Edouard Vuillard* (exh. cat.). New York, 1954.

C. Roger-Marx. *Vuillard, His Life and Work.* Paris and New York, 1946.

J. Russell. *Edouard Vuillard* (exh. cat.). Toronto, 1971-1972.

J. Salomon. *Vuillard*. Paris, 1968.

NEO-IMPRESSIONISM

R. L. Herbert. *Neo-Impressionism* (exh. cat.). New York, 1968.

J. Sutter *et al. The Neo Impressionists*. Trans. from French. Greenwich, Connecticut, 1970.

I. Compin. *H. E. Cross*. Paris, 1964.

M.-J. Chartrain-Hebbelynck. "Théo van Rysselberghe: Le groupe des XX et la Libre Esthéthique." *Revue Belge d'Archéologie et d'Histoire de l'Art* 34, no. 1-2 (1965), 99-134.

R. Marx. "Les Indépendants." *Voltaire*. December 10, 1884.

Musée des Beaux-Arts. *Rétrospective Théo van Rysselberghe* (exh. cat). Ghent, 1962.

P. Courthion. *Georges Seurat*. New York, 1968.

H. Dorra and J. Rewald. *Seurat: L'Oeuvre peint, biographie et catalogue critique*. Paris, 1959.

C. M. de Hauke. *Seurat et son oeuvre*. Paris, 1961.

J. Russell. *Seurat*. New York, 1965.

F. Cachin. *Paul Signac*. Paris, 1971.

Musée du Louvre. *Signac* (exh. cat.). Catalogue by M.-T. Lemoyne de Forges and Mme P. Bascoul-Gauthier. Paris, 1963.

P. Signac. *D'Eugène Delacroix au néo-impressionisme*. 4th ed. Paris, 1939. (Initially published as a series of articles in *La Revue Blanche* in 1898.)

FAUVISM

John Elderfield. *The "Wild Beasts"—Fauvism—and its Affinities* (exh. cat). The Museum of Modern Art, New York, 1976.

National Gallery of Art. *Aspects of Twentieth-Century Art* (exh. cat.). Washington, 1978.

Grand Palais. *André Derain* (exh. cat.). Paris, 1977.

Denys Sutton. *André Derain*. New York, 1959.

Musée National d'Art Moderne. *Van Dongen* (exh. cat.). Paris, 1967.

Pierre Courthion. *Raoul Dufy*. Geneva, 1951.

Alfred H. Barr, Jr. *Matisse—His Art and His Public*. The Museum of Modern Art, New York, 1951.

John Elderfield. *Matisse in the Collection of The Museum of Modern Art*. The Museum of Modern Art, New York, 1978.

Galerie des Beaux Arts. *Albert Marquet* (exh. cat.). Bordeaux, 1975.

Marcel Sauvage. *Vlaminck—Sa vie et son message*. Geneva, 1956.

EARLY PICASSO AND CUBISM

William Rubin. *Pablo Picasso—A Retrospective* (exh. cat.). The Museum of Modern Art, New York, 1980.

William Rubin. *Picasso in the Collection of The Museum of Modern Art*. The Museum of Modern Art, New York, 1972.

Pierre Daix. *Le Cubisme de Picasso*. Neuchatel, Switzerland, 1979.

Nicole Worms de Romilly and Jean Laude. *Braque—Cubism 1907-1914*. Paris, 1982.

OTHER TWENTIETH-CENTURY WORKS

G. Picon. *Balthus*. Musée des Arts Decoratifs, Paris, 1966.

Germaine Seligman. *Roger de la Fresnaye*. Greenwich, Connecticut, 1969.

Emily Genauer. *Rufino Tamayo*. New York, 1974.

AMERICAN

E. A. Carmean *et al.*, *Bellows: The Boxing Pictures* (exh. cat.). National Gallery of Art, Washington, 1982.

Charles H. Morgan. *George Bellows, Painter of America*. New York, 1965.

Lloyd Goodrich. *Thomas Eakins*. Cambridge and London, 1982.

Darrel Sewell. *Thomas Eakins: Artist of Philadelphia* (exh. cat.). Philadelphia Museum of Art, Philadelphia, 1982.

Lloyd Goodrich. *Edward Hopper*. New York, 1971.

Gail Levin. *Edward Hopper: The Art and the Artist* (exh. cat.). Whitney Museum of American Art, New York, 1980.

Charles Merrill Mount. "Carolus-Duran and the Development of Sargent." *Art Quarterly*, 26 (1963), 385-417.

————, *John Singer Sargent: A Biography*. New York, 1969 (first edition in 1955).

Richard Ormond. *John Singer Sargent: Paintings, Drawings, Watercolours*. London, 1970.

Andrew McLaren Young, *et al. The Paintings of James McNeill Whistler*. New Haven and London, 1980.